OIL PAINTING LANDSCAPES

A BEGINNER'S GUIDE TO CREATING BEAUTIFUL, ATMOSPHERIC WORKS OF ART

SARAH MCKENDRY

PAGE STREET
PUBLISHING CO.

PAGE STREET
PUBLISHING CO.

First published in 2023 by
Page Street Publishing Co.
27 Congress Street, Suite 1511
Salem, MA 01970
www.pagestreetpublishing.com

Distributed by Macmillan, sales in Canada by The Canadian Manda Group.

27 26 25 24 23 1 2 3 4 5

ISBN-13: 978-1-64567-986-8
ISBN-10: 1-64567-986-1

Library of Congress Control Number: 2022946885

Cover and book design by Laura Benton for Page Street Publishing Co.
Photography by Jenna Hobbs, author photo by Nicole Ashley

Printed and bound in the United States of America

I dedicate this book to my two wonderful boys, Hamish and Holden, whom I adore beyond measure, and to my incredible husband, Joel, who has always encouraged me to chase my dreams into reality.

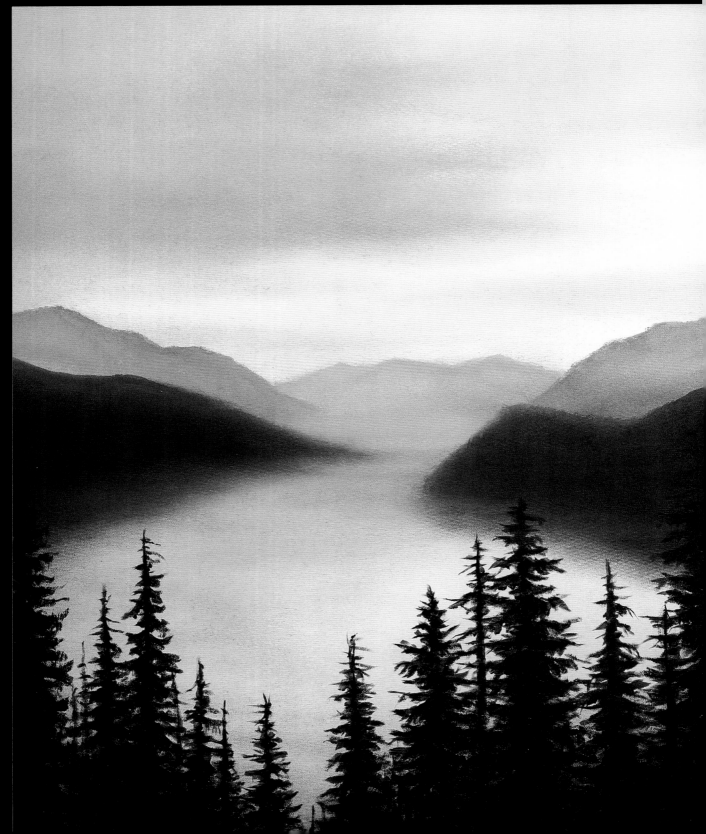

CONTENTS

INTRODUCTION TO OIL PAINTING

When I first began my journey with oil painting, I had absolutely no idea where to begin. I was dissuaded by so many people who said that oil paint was too messy to work with, too hard to clean up, took too long to dry and was far too complicated without formal training from a certified art school. Throw being a stay-at-home mom to two young boys into the equation and you can imagine my extra layer of discouragement. While this might have been enough for some people to just walk away and not bother, for me that was not an option. I am a completely self-taught artist, and up until that point, I had been exclusively using acrylic paint for all of my work. There was so much that I wanted to explore with my techniques and subject matter, but I increasingly faced limitation after limitation with the fast-drying properties of acrylic paint. I knew that if I truly wanted to flourish within my craft and thrive as an artist, I would need an entirely new medium to do so. This marked the beginning of my oil painting journey. Without any formal training, my learning curve was steep, but through perseverance, practice and indescribable amounts of trial and error, I was able to find my rhythm and flow with oil painting at long last.

I wrote this book for all the artists out there who might have been told the same inaccurate things about oil painting that I was—the artists who want to dive deeper into their self-expression with a medium that will not limit them, but don't know where to begin. This book is the perfect starting point for learning the basics of this incredibly versatile medium and to learn wonderful techniques that will get you well on your way to translating the world around you into meaningful brushstrokes on canvas.

Sarah McKendry

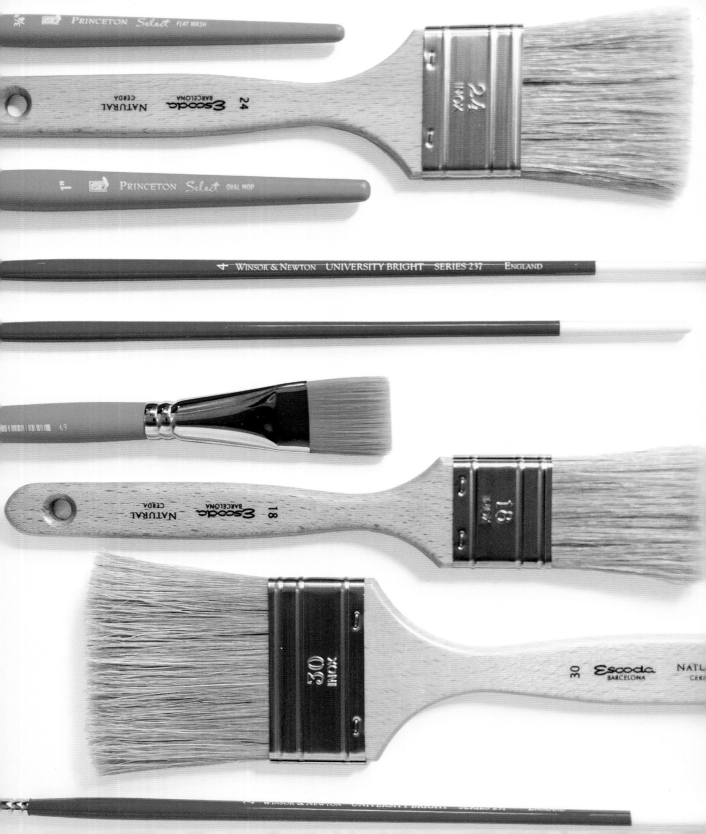

MATERIALS

Figuring out the right oil painting materials to purchase when you first start out can be an ovewhelming task if you do not have a thorough understanding of the medium itself. In this book, I have kept the material lists as simple and affordable as possible to eliminate those feelings. Feel free to substitute the colors or brushes that I list with those you already have on hand, but just be mindful that the final painting might look a little different because of those changes.

I teach students all over the world through my online oil painting classes, and over the years, many of them have expressed that they cannot find good-quality artist materials in the cities or towns where they live—especially some of the paint colors and blending brushes. I know firsthand how challenging sourcing good-quality and affordable materials can be, so to make things easier for all my students, I opened up my own online paint shop, available at www.sarahmckendry.ca/shop or through scanning the QR code featured on this page. Every single item that you need to complete the paintings within this book can be found in this shop and shipped right to your doorstep, so you can dive into this new, creative adventure quickly and efficiently.

No matter what type of paint you use or how you choose to use it, I highly suggest always creating your art in a well-ventilated space. Even though the natural mediums do not have any harsh chemicals, they can still have relatively strong smells that can easily be diminished with a simple fan or open window. Good-quality acrylic and oil paints use the exact same pigments; they just use different liquids to bind them together. People automatically assume that oil paint is the more toxic of the two, but it is actually much safer to use than acrylic paint. While acrylic paint uses an artificial binder like a resin (as well as other chemicals) to create a fluid-like consistency to the paint, oil paint uses a completely safe and natural oil as its binding agent—and nothing else. If you were to use a natural medium like walnut oil while painting and clean your brushes with linseed oil or a natural brush cleaning bar, there would be no harmful fumes at all.

OIL PAINTS

There are so many wonderful brands of oil paints to choose from, but the two most affordable brands that I use in my own studio are Winsor & Newton and M. Graham & Co. I love how their paint moves across the canvas, and their color selections are absolutely wonderful.

Below is a list of paint colors that you will need for the 12 paintings in this book, which you can find at my paint shop using the QR code on page 9 or at www.sarahmckendry.ca.

1. Titanium White

2. Charcoal Grey

3. Cerulean Blue

4. Prussian Blue

5. Indigo

6. Green Earth

7. Naples Yellow

8. Cadmium Yellow (cadmium-free)

9. Alizarin Crimson

PAINTBRUSHES

BLENDING BRUSHES

I highly recommend investing in good-quality blending brushes for your studio space. They are such wonderful tools to have on hand; they allow you to create seamless backgrounds and soft misty scenes much more easily.

My blending brushes of choice are the Escoda Single Thickness Natural Chunking Series in sizes 12, 15, 18, 24, 27 and 30, which are available at www.sarahmckendry.ca or through the QR code on page 9. The size of blending brush you should choose depends on the size of the canvas you prefer to work on. If you prefer smaller canvas surfaces, brush sizes 12 through 24 would be a good fit for you. If you like to create paintings on large-scale surfaces, then the sizes between 24 and 30 are great to have on hand.

I highly recommend having a 1-inch (2.5-cm) or ¾-inch (2-cm) flat wash synthetic bristle brush on hand for these paintings as well. They are very versatile and do a great job at blending in smaller areas of your paintings. I really love the University Select brand of brushes for this, as well as Howard Johnson synthetic brushes.

For smaller detail brushes, I like having flat or bright (rectangular-shaped bristle heads) brushes on hand in sizes 2, 4, 6 and 8. Both of these brush shapes offer a lot of versatility with detail work. I really love short-handle University Select brushes, long-handle Winsor & Newton flat or bright brushes and Howard Johnson synthetic flat brushes.

I prefer not to use any stiff bristle brushes in my paintings only because I really like the soft, smooth finish that synthetic brushes give to my work.

LOOSE BRISTLES

As you work through each of these paintings using the techniques that I show you, your larger blending brushes might shed some bristles as you paint each section. This is completely normal and happens every single time I use these techniques in my own work. Since we are going to be painting with very thin layers, try to not get caught up with removing the bristles as you are working through your painting. Wait until your painting fully dries and then gently rub your fingers across bristles on the canvas to loosen them. They should fall right off.

CANVASES

SIZING

Whenever you buy a stretched canvas in a store, you have two canvas depths to choose from: standard depth (¾ inch [2 cm] thick) or gallery depth (1½ inches [4 cm] thick). Every painting in this book was created on gallery-depth stretched canvas.

One thing to keep in mind when you are shopping for canvas is that the gallery-depth canvases have frames and cross braces that sit slightly farther back from the rear surface of the canvas, which makes it easier to apply more pressure with your brush while you are working on your painting. Sometimes the frame sits very close to the back of the canvas (standard depth), and the outline of that frame can show through on the front of your painting while you are doing your blending work. If this happens to you while you are working on your piece, do not worry! Very gently work that area again with the same circular brush motions, and the lines will disappear quite easily.

The canvas sizes listed for each painting in this book are only a suggestion. Please feel free to use whatever size you have on hand or whatever size you are most comfortable with. If you do use a different canvas size than what's suggested, try your best to scale the suggested size up or down so that the composition remains the same for your painting. This will make following along much easier for you.

PRIMING

Before you begin painting on any canvas, you must make sure to prepare the surface for your paint. Most canvases can be purchased already primed, but you should also add a layer or two of gesso on top before you begin. Gesso, a white paint mixture consisting of a binder mixed with chalk, gypsum or pigment, is used to prepare the surface for paint. It ensures your paint fully adheres to the canvas.

To apply gesso to your canvas, you just need a synthetic acrylic blending brush. Cover the surface of your canvas with smooth, even brushstrokes and let it dry for 24 hours before you begin painting on it. It's as simple as that!

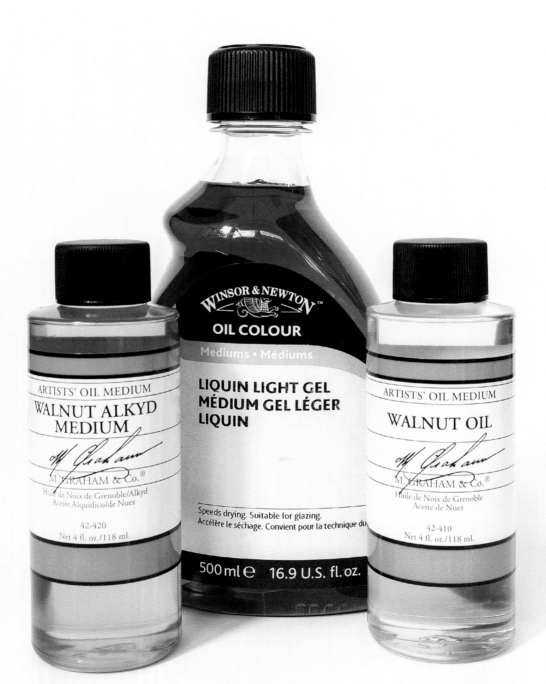

MEDIUMS

An oil paint medium is a liquid that you add to your paint to change how it performs as you use it. Mediums exist to alter the viscosity and transparency of the oil paint, to speed up or extend drying times and to improve cost efficiency (by helping small amounts of paint go a longer way). There are multiple kinds of oil painting mediums available on the market, and each one produces a different result. For the sake of simplicity and because they are my favorite mediums to use, I suggest sticking to M. Graham & Co.'s Walnut Oil and Walnut Alkyd Oil and Winsor & Newton's Liquin Light Gel for this book.

It is very important to understand how a medium affects your paint before you begin to work with it. Not only does a medium make your paint thinner, it also determines how long the paint will take to dry as you work through your projects. In this book, we will be painting with extremely thin layers of paint. The reason I do this is because I like to paint using the wet-on-wet technique. This means that I do not wait for layers to dry before moving on to the next stage of my painting. By only using a small amount of medium in the base layer of my paintings, any subsequent layers that I paint over that base layer will pick up some of the medium beneath it.

Although I prefer to use the wet-on-wet technique, that does not mean that you have to. You can work through each painting in this book at a pace that feels right for you. The medium that you choose for your painting, however, will be an important determinant in deciding how long you want to wait in between each painting session. If you choose to use a medium like walnut oil, you will need to wait 4 to 5 days for your painting to dry before continuing. If you choose to use Walnut Alkyd Oil or Liquin Light Gel, you will only have to wait 24 to 48 hours for it to dry.

Walnut Alkyd Oil: This all-natural alkyd medium made by M. Graham & Co. speeds up the drying time of oil paint substantially. Paintings with thin layers are usually dry within 24 to 48 hours.

Walnut Oil: This all-natural walnut oil medium (I prefer the oil made by M. Graham & Co.) extends the drying time of paints. Paintings with thin layers are usually dry within 4 to 5 days.

Liquin Light Gel: This quick-drying gloss medium made by Winsor & Newton speeds up the drying time of oil paint substantially. This is not a natural medium and should be used in a well-ventilated space. Paintings with thin layers usually dry within 24 to 48 hours.

Understanding the proper amount of medium to add to your paint takes a lot of practice and play. To give you an idea of what consistency you should strive for while working through this book, I have provided three examples for you to consider.

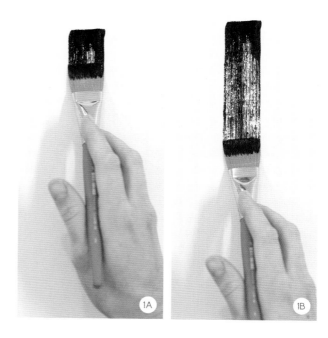

For all three examples, I'm using Prussian Blue and Walnut Alkyd Oil as the medium.

1. When you do not add any medium to your paint and you apply it to your canvas right out of the tube, this is the consistency it will have when you pull your brush down the canvas using a medium amount of pressure. Notice how the color does not stay uniform as you pull your brush down. This is the consistency that you want your paint to have as you work through the final layers of each painting in this book.

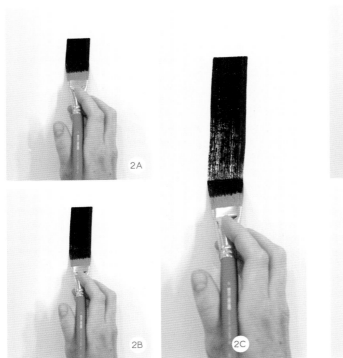

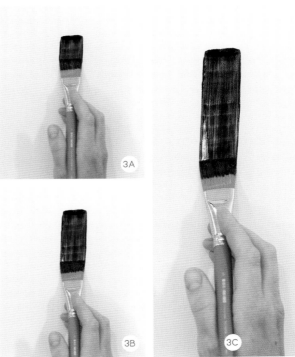

2. When you add 2 to 3 small drops of medium to your color, it will become much easier to pull your brush down the canvas while using the same amount of pressure as before. The trick to finding the perfect amount of medium is to add small amounts of it at a time to the color that you are working with. Your paint should have a slightly fluid-like feel at the beginning of your brush-stroke, and it should lose that fluidity near the end as you pull it down the canvas.

3. When you add too much medium to your paint, it will move very easily down the canvas, and the color will become much more transparent. This is not the consistency of paint that you should have when you're working on the paintings in this book. If you use this much medium in any layer of your painting, then all of the blending techniques I teach in this book will be quite hard to grasp.

I highly suggest experimenting with adding different amounts of medium to your paint to get a feel for how it changes in consistency as you apply it to your canvas. A good thing to know as you're working through a painting is that if you happen to add too much medium to any area, it is easy to correct without having to start an entirely new canvas. Just use a lint-free paper towel or a painting rag to wipe off the section that has too much medium, and start the process again, making the necessary adjustments to your palette as you go.

CLEANING UP

As you are working through the paintings in this book, it is very important to not clean your brushes in between each step. All you need to do is wipe the excess paint from the brush onto a rag or paper towel and carry on. The reason why this is so important is that the bristles of your brush will hold on to the solvent or medium that you use to clean your brushes. The solvent will greatly alter the consistency of your oil paint. Once you are finished painting for the day, then you can properly clean your brushes and allow them to fully dry before using them again.

Cleaning up oil paint does take a little bit more elbow grease than any other type of paint, but once you establish a routine and have a good understanding of how to best clean and care for your brushes, it gets easier. There are many ways to clean oil paint off your brushes, and you can find a short brush cleaning demonstration on my website at www.sarahmckendry.ca, as well as step-by-step tutorials for various methods online. Some great options to investigate are cleaning brushes with linseed oil, cleaning brushes with a special soap bar or, if you have proper ventilation and storage, cleaning your brushes with odorless solvent.

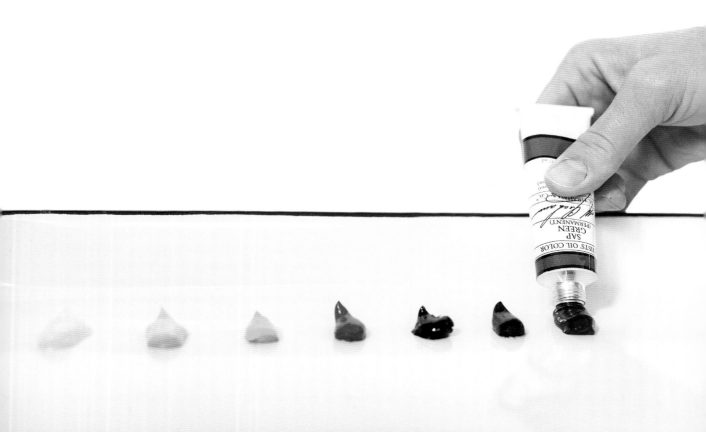

COMPOSITION

A very important aspect of creating realistic oil paintings is learning how to create a pleasing composition for the eye. One of the most commonly used composition techniques is called the rule of thirds. This is an important concept that can be used across all creative fields, and it will help produce artwork that is captivating and well balanced.

The rule of thirds involves dividing your reference image into a grid with two horizontal lines and two vertical lines, creating nine equally proportioned boxes. The main compositional elements of your image should rest on any of the intersections or lines of that grid. This could be a group of trees, a horizon line, a bit of sun backlighting a cloud, or anything that draws the viewer's eye into a specific section of the painting.

Throughout this book, I'll refer quite often to the bottom-thirds line and the top-thirds line. These are the two horizontal grid lines that we will be focusing on for most of the paintings. Although I do not draw this grid on the canvas as I am working on it, I always imagine that it is floating right above the surface, and I use it to remind myself where my focal point should be resting.

When you are first starting out and just getting the hang of how to properly block in the composition of a painting, you can use a ruler and a pencil to softly mark out the grid lines on your blank canvas before you begin. Your paint will eventually cover these lines as you work on the scene, but it will give you a great starting point for where you want to place your focal point when you begin painting.

If you ever feel as though you have lost the focal point or if the composition feels a little off as you work through your painting, use an old ruler or a straight edge to gently reestablish the grid and get yourself back on track. You can then softly blend in the lines you created after you are happy with the corrections you have made.

Here is an example of what the rule of thirds grid looks like when placed over top of one of my paintings. As you can see, the horizon line rests directly along the bottom-thirds line. The focal point of the painting is the cluster of bright yellow bushes that is surrounding the intersection of the two grid lines on the right side of the canvas. This simple layout creates a truly beautiful balance within the composition of the painting.

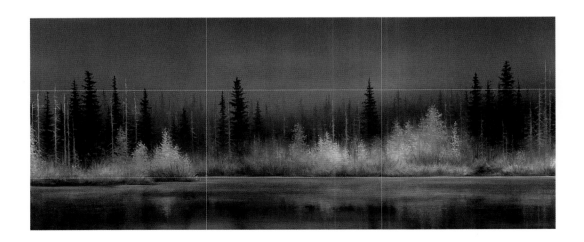

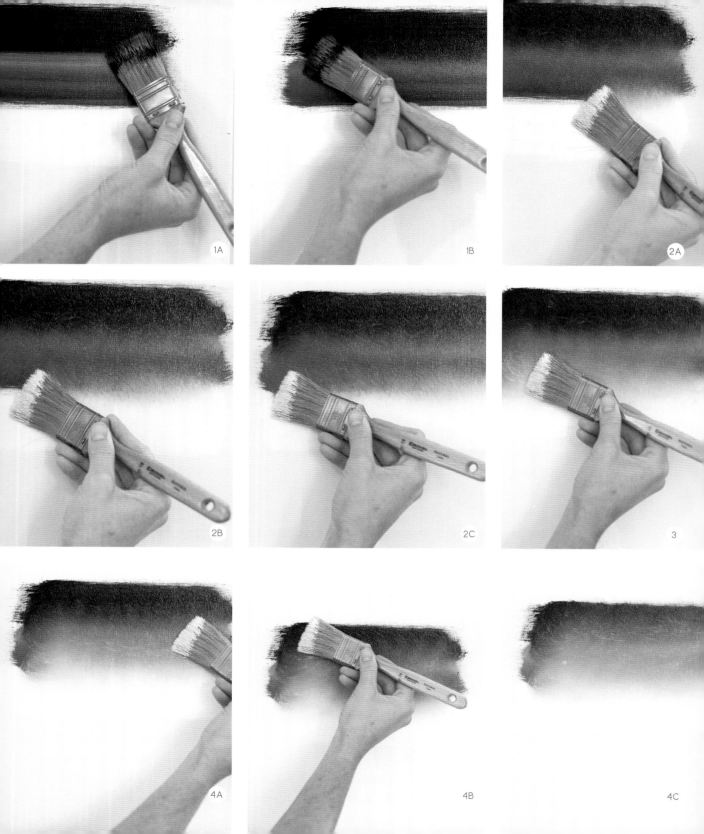

1A

1B

2A

2B

2C

3

4A

4B

4C

TECHNIQUES

BLENDING

If there's one thing that you will get quite good at by the end of this book, it is blending transition lines. A transition line is where two different sections of paint meet on a canvas. Often you will need to blend those two transition lines together to create a seamless look for your background.

With this demonstration, I am going to show you how to softly blend a transition line. These techniques take many hours of practice to figure out, so be sure to spend time getting the hang of the amount of paint to use and brush pressure you need to achieve a realistic look with this technique.

1. Using your size 24 blending brush, establish three lines of paint across a small section of a practice canvas. You can use any color you like for this; just be sure to only add a very small amount of medium so your paint has a slightly thicker consistency. The bottom line should be Titanium White, the middle line should contain Titanium White as well as your blending color and the top line should just be your dark blending color.

2. Wipe all of the excess paint off of your brush onto a rag or paper towel. It does not have to be completely clean; you just don't want any excess paint on your brush before you begin working on the transition lines. Place your blending brush on the righthand side of the canvas, resting on the transition line between the medium color and the darkest color. Using very small circular motions and a gentle amount of pressure, slowly work your brush across that transition line from right to left. Wipe off your brush and repeat this process with even less pressure but slightly larger circular motions. You can repeat this action as many times as you need until the transition line looks soft and even.

3. Once you are happy with the top transition, it's time to begin working on the transition line between the bottom and middle colors. Repeat the exact same process as before, making sure to wipe your brush off after each pass.

4. The final step to creating seamless transitions is to work your brush back and forth up the entire surface area using small circular motions. Make sure that you wipe all excess paint off your brush before beginning this final step, and to only have a minimal amount of pressure on your brush as you work it along the canvas. After you make your first pass across the bottom, move your brush up half of a brush width (1 to 2 inches [2 to 5 cm]) and then do another pass. Keep moving your brush up half a brush width all the way up the canvas, remembering to wipe your brush off every three passes or so before continuing on. You can repeat this process as many times as needed until you are happy with how your transitions are looking. Remember that this takes a lot of practice, so go easy on yourself and keep working on it until you feel it beginning to come together for you.

PAINTING EVERGREEN TREES

I want to walk you through how to create a simple evergreen tree that we will be using in many of the paintings found within this book. There are lots of things to remember when it comes to painting realistic trees.

For instance, branches at the top of the tree are shorter and thinner than the branches found at the bottom of a tree. There does not have to be a big change in the length of the branches as you work down the tree; it should actually be quite subtle.

No single tree is perfect in symmetry and composition anywhere in the natural world. If you were to create a tree that has no subtle nuances or variations, it would end up not looking realistic at all. Make sure that each tree in your painting is a little different than the ones surrounding it.

Every forest scene should have a dead, standing tree somewhere within it. This mimics how a forest looks in real life, and really creates something interesting for the eye when looking at your painting.

Your brush should rest softly in your fingertips when you are working on a tree. One of my favorite tricks to creating realistic trees in my paintings is to allow the brush to roll through my fingers as I pull a branch away from the trunk. Having your brush loose and free flowing in your hand as you work really allows unique branches to form on your trees. You should focus on trying to create unique shapes and lines with each branch. You should also add some dead limbs on your tree to make it look more natural. Practicing how to create these trees will really help create realistic-looking landscapes.

With these tips in mind, use your smaller detail brush to mix a tiny bit of medium with whatever color it is that you have on hand. I am using Green Earth in this demonstration.

1. To begin your tree, paint a straight line from the top of where you want your tree to begin down to the bottom of where you would like it to end. Painting straight lines can be tricky, and although it truly does not matter if your line is perfect or not, you are welcome to use a ruler or straight edge to establish your tree trunk at this stage.

2. With the same brush and a little bit more paint added to it, begin adding branches to your tree from the top. Gently roll your brush through your fingertips from the trunk out a little way, adding small tufts of evergreen needles or little twigs to each branch as you go.

3. Continue adding branches down the entire length of your tree, making sure that each branch is ever so slightly longer than the one above.

Keep practicing creating trees like this and introduce different brushstrokes to see what effects they have on your tree and if you prefer that more. The creative process is so much fun, and the more time you spend here exploring and playing with different techniques, the more enjoyable the paintings in this book will become for you.

WET ON WET

There are two ways that you can work through an oil painting. You can paint a single layer then wait for that layer to fully dry before moving on, or you can paint directly on top of wet paint without allowing the lower layer to dry at all. This second process is called the wet-on-wet technique, and it is my preferred method of painting. Painting wet on wet takes a lot of practice, especially when you are first starting out, so I highly suggest taking your time with the projects in this book and allowing your paintings to fully dry as you work through the steps. As you gain confidence with your brushwork and blending, you may find that the wet-on-wet technique comes easier to you, and this is when you should begin exploring even more.

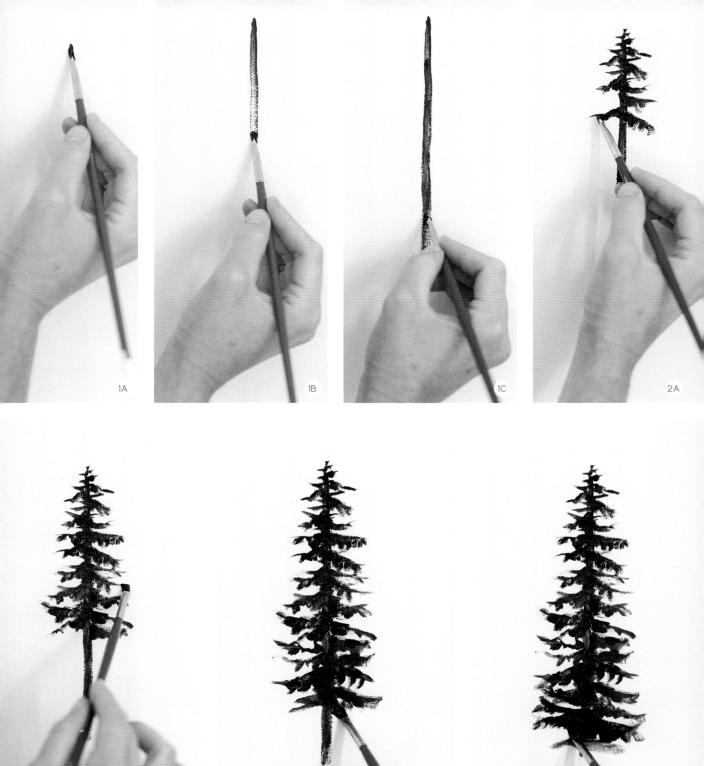

1A

1B

1C

2A

2B

3A

3B

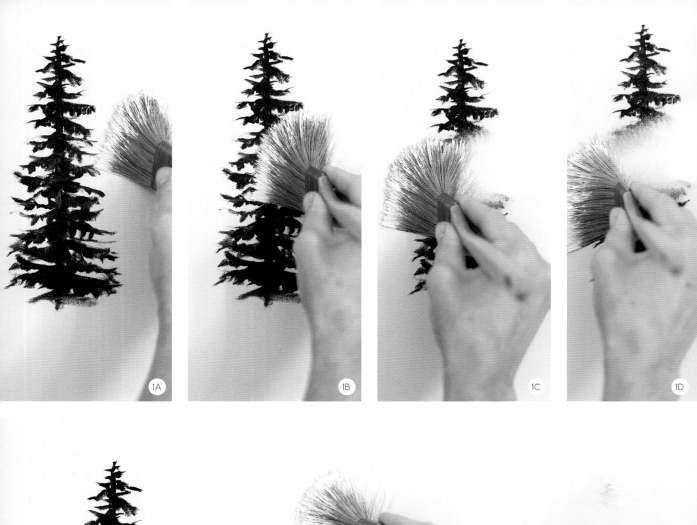

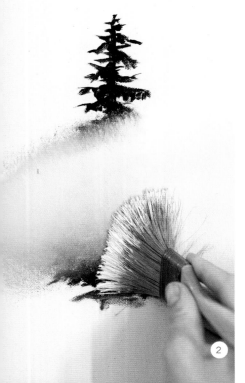

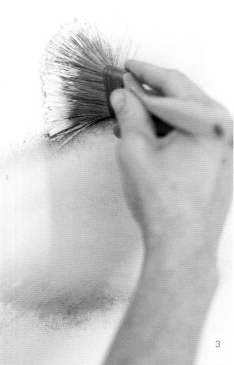

FIXING MISTAKES

I can't begin to tell you how many times I have been working on a canvas and needed to fix something that just didn't feel right within my painting. One of the reasons why I love oil painting so much is that you are not stuck with what you first put down on the canvas and that you can easily fix what you need to long before the paint ever dries. A fun way to fix a mistake in one of your paintings is to blend that "happy little accident" right out of your painting all together.

1. To do this, take a clean blending brush with the same color on it as the background you will be blending into. In this case, I have white on my brush and no medium mixed into it at all. With a lot of pressure on your brush and using large circular motions, begin pushing your brush across the surface of the object that you are wanting to erase. In this case, I am erasing the tree I just painted.

2. Do not let up on your brush pressure as you work across the surface area. After the first pass across, wipe all of the excess paint off of your brush on a paper towel or rag.

3. Pick up a little bit more background color with your brush and start the process all over again, moving your brush slightly below the area from your first pass. With the same amount of pressure on your brush, do the exact same thing as before. You'll see how quickly that tree disappears as you do so.

4. Wipe off your brush and repeat this process as many times as you need until your little problem area has vanished from sight.

Another way to remove a section of your painting that doesn't feel right is to take a paper towel or a rag and gently rub it over the section that you'd like to fix until the paint comes off. This technique works really well in sections of paintings where you already have a lot of detail work built up, and you don't want to mess it up with those larger brushstrokes.

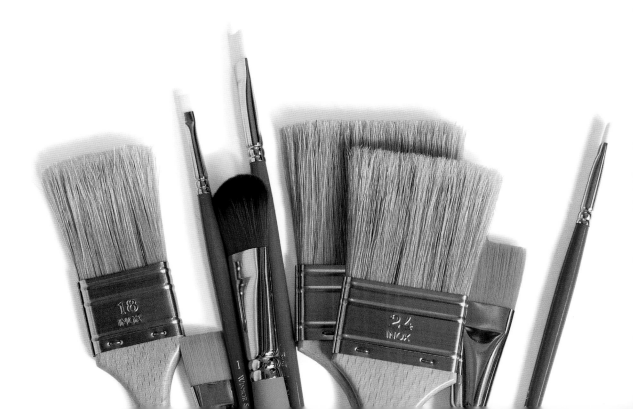

PAINTING
LANDSCAPES

One of my favorite things to do when I am out exploring the incredible mountain ranges, ancient forests and rocky shorelines of the Pacific Northwest is to imagine how I can take all the indescribable beauty that I see and somehow translate it into brushstrokes on canvas. I have dedicated my entire creative journey to figuring out how to capture that magic while using only a few simple tools, and I am so excited to show you all the tips and tricks that I have learned along the way.

From soft ocean sunrises to moody mountain ranges, these 12 beautiful paintings will give you the skills you need to turn your favorite scenes in nature into realistic pieces of art.

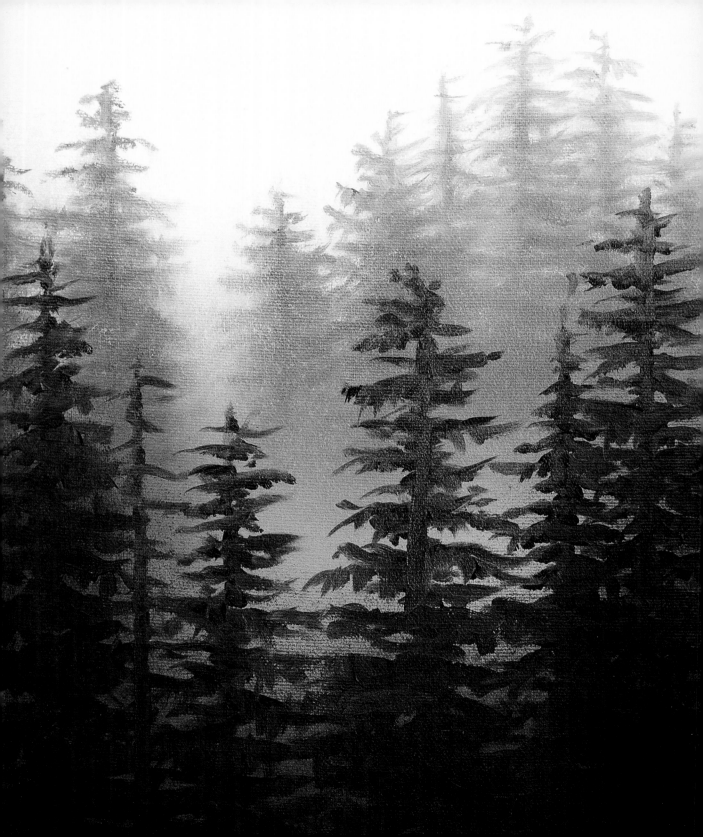

MISTY LAYERED FOREST

There is something so serene and tranquil about mist as it settles into a landscape, and figuring out how to translate that into a realistic painting has been such a fun adventure on my creative journey.

I am going to break down how I created this 9x12-inch (22 x 30-cm) misty layered forest in easy-to-follow steps. Make sure you take your time in each stage of this painting because the more time you spend practicing each technique, the more realistic your paintings will begin to look.

MATERIALS

Canvas Size: 9 x 12-inch (22 x 30-cm) canvas
Paint Colors: Titanium White, Green Earth, Indigo, Charcoal Grey
Medium: Walnut Alkyd Oil (speeds up drying time) or walnut oil (slows down drying time)

BEFORE YOU BEGIN

The focal point for this painting is the slight gap in the background layer of trees that sits around the upper thirds line. The misty layer that rests in front of the background trees is really going to draw the eye toward that focal point.

As you work through this painting, be sure not to wash your brushes in between any of the steps. If you only have a few brushes on hand and need to reuse them, just wipe your brush back and forth on a paper towel or a rag repeatedly until all of the excess paint comes off. The reason why you do not want to wash the brushes as you are working through this painting is because the brushes will hold whatever cleaning solution you use within their bristles, which will thin out the paint and make the blending work very challenging.

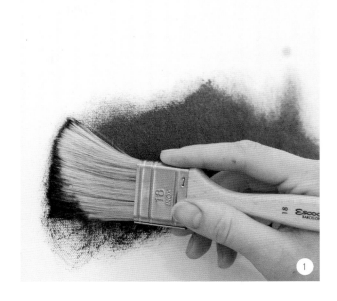

THE PROCESS

1. We are going to start the blending work for our background with the darkest color that we will be using. On your palette, mix equal parts Green Earth and Indigo and a tiny bit of Charcoal Grey together. Add very small amounts of the medium you are using to this mixture until your paint is slightly thinner than what it is like when it comes out of the tube.

 With your size 24 blending brush (or whatever brush you will be using), begin transferring that color into the bottom third section of your canvas using a lot of pressure and large circular motions. Make sure your layer of paint is very thin. You should not see any globs or thick sections of paint on your canvas throughout these next steps. If you feel as though you might have too much paint on your canvas at any point, just wipe the excess paint off with a paper towel or rag and then continue.

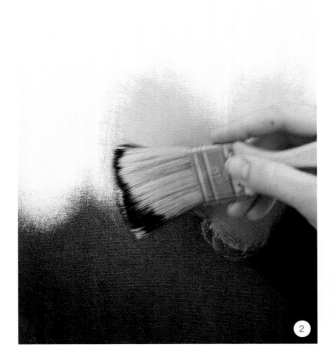

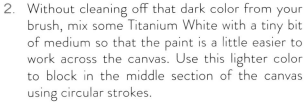

2. Without cleaning off that dark color from your brush, mix some Titanium White with a tiny bit of medium so that the paint is a little easier to work across the canvas. Use this lighter color to block in the middle section of the canvas using circular strokes.

3. Wipe all the excess paint off your brush onto a paper towel or rag. With a very little amount of pressure, start gently working the bottom transition line between the two colors with small circular motions back and forth across the canvas until the color softens.

 Clean off your blending brush by wiping all of the excess paint onto a paper towel or rag. Using that same brush, mix Titanium White and a tiny bit of medium together on your palette. Block in the top section of this canvas with a very thin layer of paint using the same blending technique as in the previous steps.

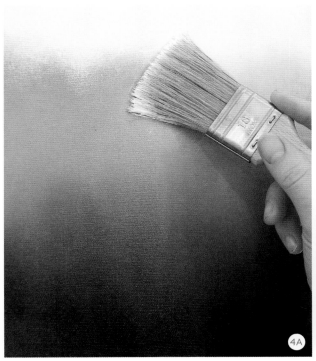

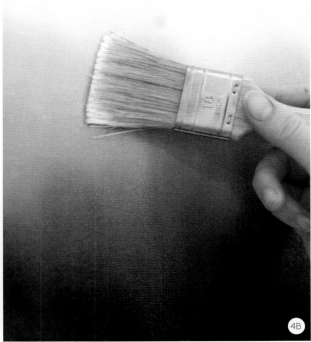

4. After you blend the white across the canvas, start working on the transition line between the top section and the middle section that you have just blocked in. With very little pressure on your brush, start softening the transition line by using small circular motions back and forth across the canvas.

For this transition line, you want to give the illusion that a line of trees is resting way off in the distance, and this subtle brushwork will leave you with a smooth transition that is barely visibile.

5. Once you are finished blending in the background, you can either wait for your painting to fully dry before you begin the next steps, or you can continue using the wet-on-wet technique.

If you do choose to wait for your painting to fully dry, you should be able to run your hand across the surface of your painting without any paint transferring onto your skin; it should not feel tacky at all. If you begin painting on your canvas before it fully dries, you risk ruining the base layers that you have just created, so be sure to be patient with the drying time.

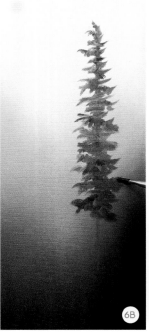
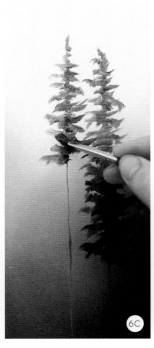
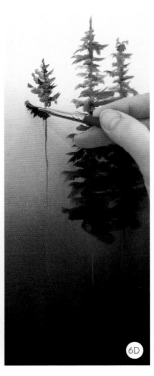

6. If you look at the final painting (page 26), you will see that there are two layers of trees. You always want to work from the background to the foreground when you are creating a landscape, so the next step will be creating the trees that rest in the top third section of the canvas.

If you have opted to allow your canvas to fully dry in between steps for any projects within this book, you will need to add a few small drops of medium to your paint when you begin working on your painting again. This will allow your paint to flow easier for you as you work through the remainder of the steps.

Using one of your smaller detail brushes, create more of that dark color that we used for the base layer of the background. You should use equal parts Green Earth and Indigo for your mix, as well as a tiny hint of Charcoal Grey. If your paint is very thick, add only a very tiny bit of medium to help thin it ever so slightly. You do want to keep this mixture quite thick because some of the medium that you added to the base layer will be transferring up into the new color as you apply it to the canvas, if you're using the wet-on-wet technique.

Using the tree building techniques that you practiced at the beginning of the book (page 20), start creating a line of trees from right to left across your canvas near the top-thirds line.

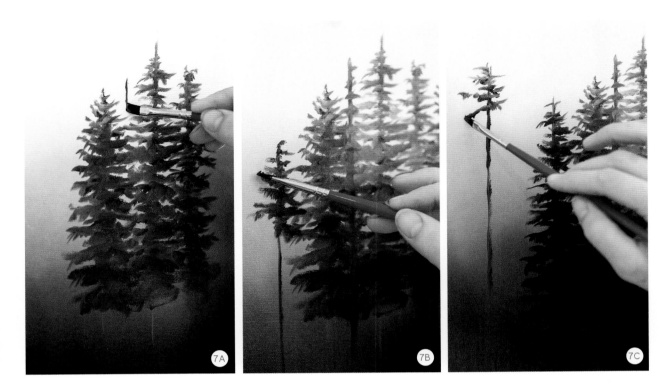

7. As you are creating these trees, make sure that they are all different heights and that the branches are all a little different, too. This will help your scene look more realistic, as no two trees are the same in the natural world.

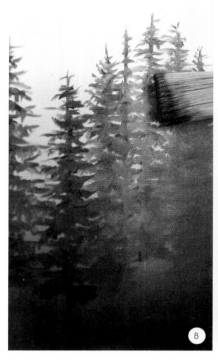
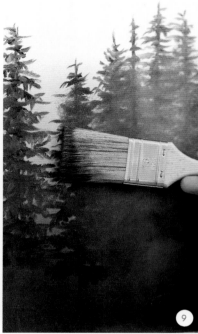
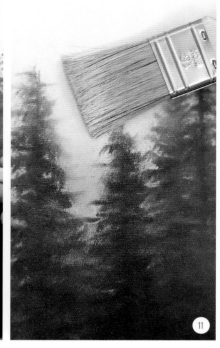

8. Once you've finished this middle section of trees, pick your larger blending brush back up and wipe off any excess paint that is on it. You want to have only a tiny bit of paint on the bristles. With this brush, we are going to gently soften all the edges of the trees you just created.

9. Using an extremely light amount of pressure on your brush so it's barely touching the canvas, use small circular motions to go over the lower half of the trees you just painted. Don't go all the way up to the top of the trees in this step; just focus on softening the bottom portions.

10. If you happen to push a little too hard and your trees lose their shape and definition, all you have to do is use your detail brush to re-paint the trees

back into the scene. After you reestablish your tree line, wipe off that blending brush and just use less pressure than you did before to soften the trees.

11. We are now going to do the same thing to the tops of those trees. Add a little bit of Titanium White to the bristles of a clean blending brush, then gently wipe off any excess paint so there is only a small amount left on your brush.

With very gentle circular motions and barely any pressure on your brush, move your paintbrush throughout that light sky section, gently going across the top of those tree tops that you just created.

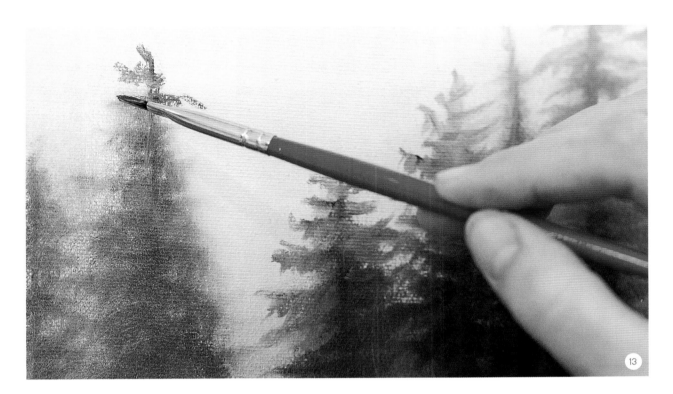

12. Getting used to the really subtle differences in pressure with your brush across the canvas takes a lot of practice, and trial and error. If you happen to press too hard, try your best to not get discouraged. The wonderful thing about oil painting is you can keep working on certain sections over and over again until you get them just right, without having to worry about anything drying too fast.

13. Once you're happy with how your first layer of trees looks, take a detail brush and gently add a little bit of detail back to the trees.

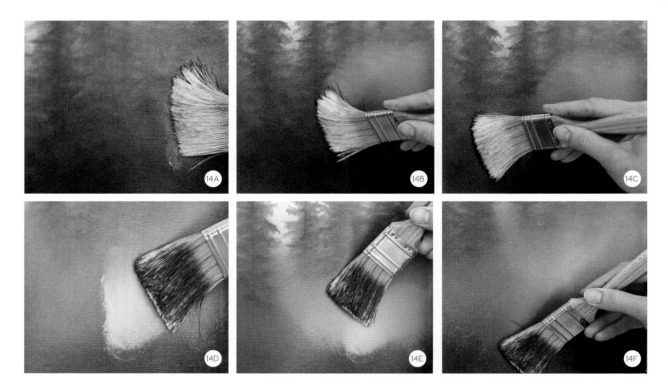

14. The next step to this painting is creating the misty layer that sits in front of those trees that we just created. Wipe off your blending brush so there is no excess paint on the bristles and mix a tiny bit a Titanium White to the end of your brush.

 With a lot of pressure on your brush, move it in a circular motion from left to right, creating a soft misty layer in front of the trees. After you finish your first pass, add some more Titanium White to your brush and continue to build up the mist until you are happy with how it looks.

A simple trick to remember when you are doing your blending work is that after you make one pass across the canvas with your circular motions, if you flip your paintbrush over, it should only have the lighter color on that side. By using this fresh side of the brush on your next pass, you are just saving yourself from having to wipe it off. Once both sides have been used, then you can wipe off all of the excess paint on a paint rag and continue on.

15. If you need to, this is a great place to stop and let your painting dry once again. You have established a really soft and seamless background, and it will be very easy to finish the painting after it has dried.

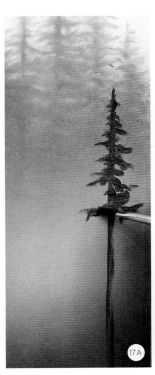

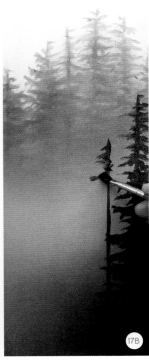

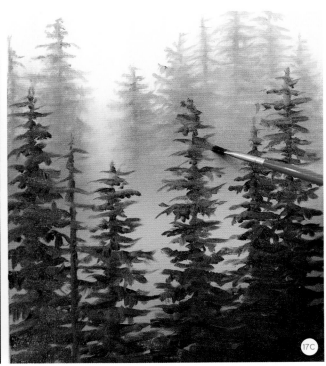

16. The final stage to this misty forest scene will be creating the line of trees that sit in the foreground. You want these trees to be nice and dark, so mix together some Green Earth, a tiny bit of Indigo and a tiny bit Charcoal Grey on your palette.

You should not need to add any medium to your paint for this final tree layer but, if you are finding that the paint is tricky to move along the canvas, you can add a very small amount if needed.

17. Using the exact same techniques that you used for the background layer of trees, begin creating with the fine detail brush a line of trees in the foreground that are various heights and distances apart.

There will be no more blending work in this final stage, so spend some time and have fun!

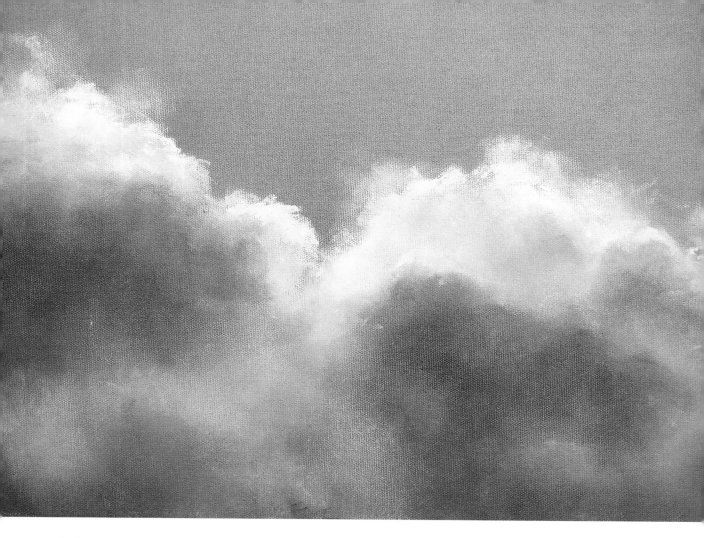

CLOUDBURST

Bringing a beautiful cloudscape to life is one of my favorite things to do as an artist. There are so many wonderful techniques you can use to create realistic looking clouds, and I am so excited to share some of them with you.

In this 12 x 16-inch (22 x 30-cm) cloud painting, I will break down each step into easy-to-manage sections. This painting is a lot of fun to create, and I encourage you to explore how different movements of your brush can transform your scene.

MATERIALS

Canvas Size: 12 x 16-inch (30 x 40-cm) canvas
Paint Colors: Titanium White, Indigo, Prussian Blue, Cerulean Blue, Green Earth
Medium: Walnut Alkyd Oil (speeds up drying time) or walnut oil (slows down drying time)

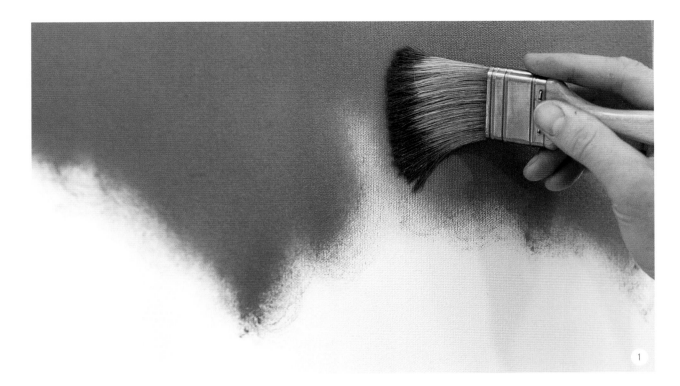

BEFORE YOU BEGIN

Try to allow your brush to have some softness within your hand as you work on this canvas. By using all of the edges of the brush and playing with different amounts of pressure, you will begin to create clouds that have subtle imperfections; these nuances will help to create a realistic-looking sky scene.

To create a balanced composition for your painting, try to keep the tip of your clouds just above the top-thirds line on the left side of the canvas, with them gradually lowering in height down towards the bottom-thirds line on the right side of the canvas. This will really create a pleasing image for the eye with the finished piece.

Make sure that you do not use too much medium when you are mixing the different colors for this painting. You want to be able to do lots of subtle blending work within the different layers of this cloud-scape; having a thicker consistency to the paint will make that blending much easier for you.

THE PROCESS

1. Using one of your size 24 blending brushes, mix some Cerulean Blue, Prussian Blue, and a little bit of Titanium White on your palette until you create a soft blue that's similar to the color I have in the photo. You can add a tiny bit of medium to this paint so that it moves easily across the canvas with your blending brush.

 Begin establishing the shape of the clouds you would like to have in your painting by filling in the upper section of your canvas with this color.

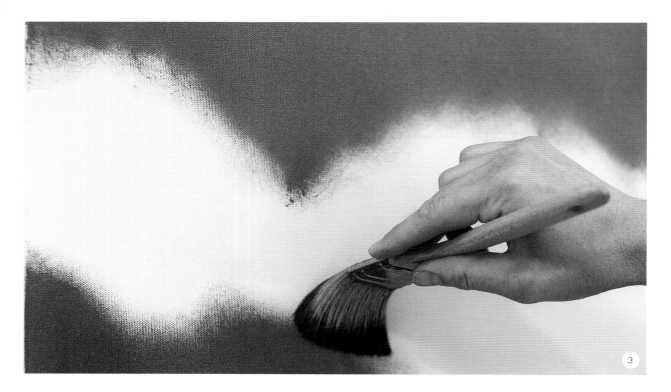

2. It's important not to bring this blue too far down into where your clouds are going to sit. The reason for this is because you don't want this blue to overpower the other colors that we use later in the process.

3. After you establish the background layer for your sky, we get to make a fun shadow color that we're going to use for our clouds. On your palette, mix some Prussian Blue, Cerulean Blue and some Green Earth together. You want this color to have slightly more green than blue in it, so be mindful of that.

 With a lot of pressure on your brush, while working in small circular motions, begin transferring this color onto your canvas where you would like the shadows of your clouds to sit.

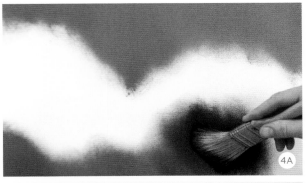

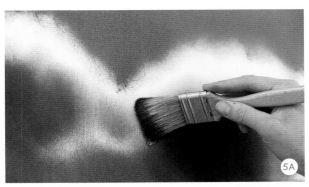

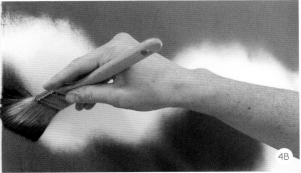

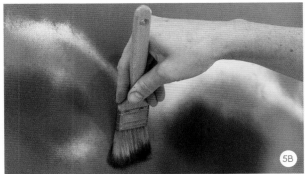

4. With the same brush, add a tiny bit more Prussian Blue to the mixture and continue blocking in a few more shadow areas for your clouds.

5. Without cleaning off the brush you are using, add some Titanium White, and fill in the remaining white sections of your canvas that have yet to be painted. Be sure to leave roughly 1 inch (2.5 cm) of white canvas exposed along the tops of your clouds, because this will allow our highlight work to pop a lot more when we get to that stage.

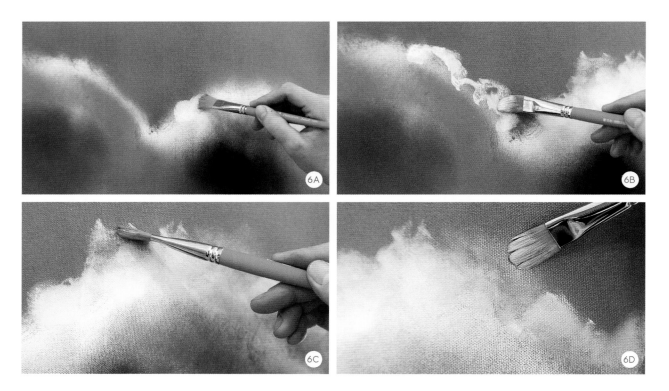

6. Now for the fun part. This is where the clouds will really begin to take shape on your canvas. With your ¾-inch (2-cm) or 1-inch (2.5-cm) blending brush, pick up some Titanium White from your palette, and start gently working it along where you want the tops of your clouds to sit in your scene. If you allow the brush to sit lightly against your fingertips and gently roll it across the canvas in different sections where you want a highlight to be, it creates wonderful shapes and three-dimensional effects within your clouds.

 In the natural world, clouds often have little fluffy wisps coming off them. To create that look within your painting, add some Titanium White to your 1-inch (2.5-cm) brush and, with a very gentle amount of pressure, allow your brush to transfer a very thin layer of paint into different sections near the tops of your clouds. This is a very subtle brushstroke, and you can do it anywhere that you want to add a little more magic to your cloudy scene.

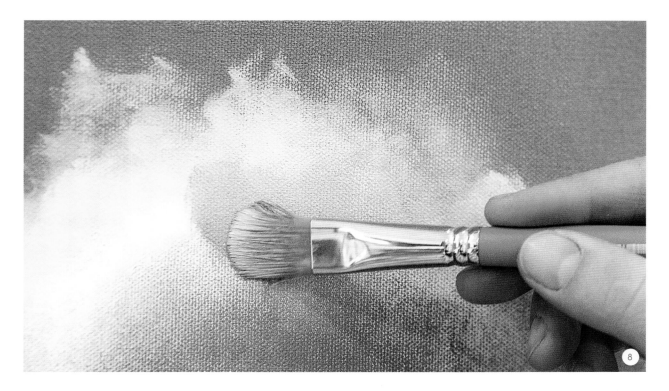

7. These techniques take a lot of practice to master, but by spending the time in each section and really allowing yourself to let loose and explore, you're setting yourself up for success on your creative journey.

8. The next step of this painting is to begin softly blending the transition lines around the shadows that we blocked in earlier. With a 1-inch (2.5-cm) blending brush and a tiny bit of Prussian Blue, gently apply the color in a few of the areas where you feel that the shadow would look really pronounced on the cloud. This is the same technique that we use with our big blending brush: soft circular motions with barely any pressure on the canvas.

Wipe off your brush to remove any excess paint and then gently begin working your brush around all of the transition lines that are in the clouds. The goal of this step is to soften all of the edges between light and shadow in a subtle way.

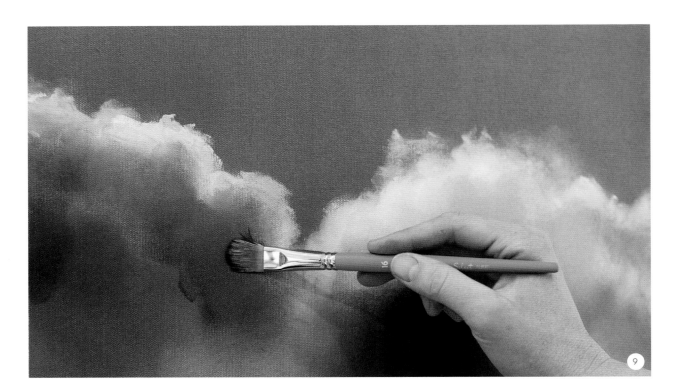

9. After you have gently blended all those transition lines, clean off your large blending brush using a paper towel or rag. Then, mix together a very tiny amount of Prussian Blue and Titanium White on your palette. Using barely any pressure on your brush, gently transfer this color into the midsection of your clouds to add a little bit more dimension to the space. This will help draw the eye toward the focal point.

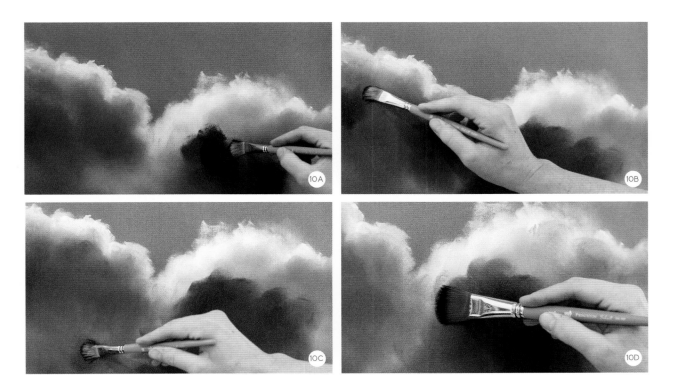

10. Wipe off your brush and then mix some Prussian Blue and a little bit of Indigo together on your palette. Begin transferring this color into sections of your foreground where you feel like a nice dark shadow would sit. I like to make these shadows roughly half the size of the cloud that I am working on, and I keep this dark color 2 to 3 inches below the top section of my cloud.

Once you have added this dark shadow color to your clouds, wipe the excess paint off of your brush or use a fresh brush and, with gentle circular motions, begin softening the harsh transition lines between the dark sections and the light sections. You are only trying to soften the edges on the transition line a little bit, so you should only need to do one or two passes.

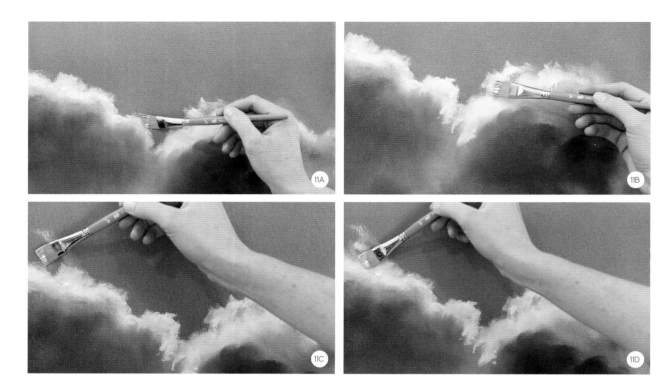

11. Wipe off your 1-inch (2.5-cm) brush and add a small amount of Titanium White to it. With soft, loose brushstrokes, begin pulling some wisps of cloud up from the top of your cloud line. This really captures the attention of the eye when it looks upon the scene.

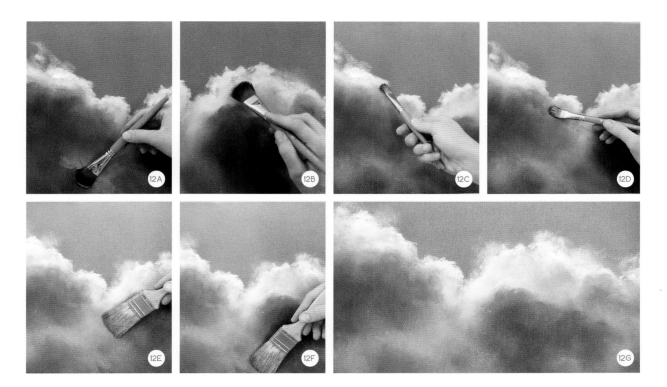

12. Using different brushes that are wiped clean, gently soften some of the transition lines that might look a little too harsh on your clouds. Make sure to step back from your painting and to not get too carried away with this step. You do not want to over-blend all of the layers you created. You just want to soften a few of them to help things look cohesive.

If you notice that your brush is picking up hints of blue paint as you work through this step, be sure to wipe it off on a paper towel or rag in between your passes. You can then add a little bit more Titanium White to your brush and continue on with blocking in your clouds.

13. Be sure to have some fun playing around with how you want your final painting to look now that we have brought it to this final stage.

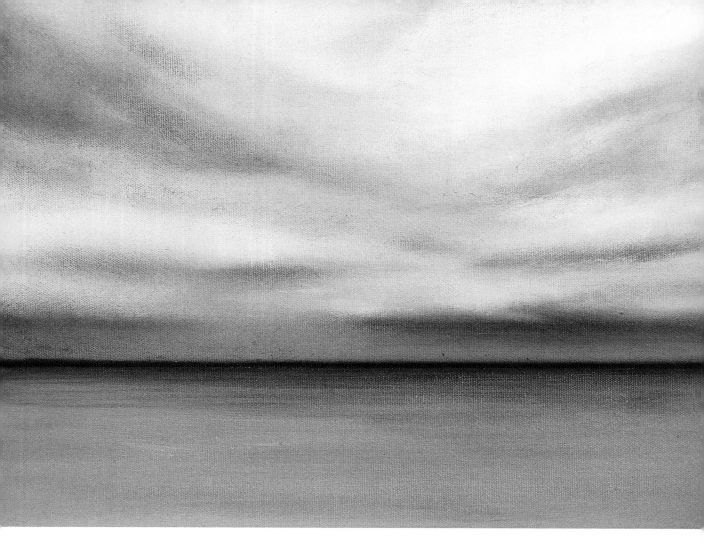

SOFT BLUE OCEAN SCENE

In this painting, we are going to play with some moody blues and practice how to achieve softness with our brushwork. I love the feeling of calm that washes over me when I work on paintings like this, and I hope that you can find some moments of Zen as you work through this painting, too!

In this 12 x 16–inch (30 x 40–cm) painting, I will show you how to block in layered shadows and how to create soft wispy clouds over still ocean water.

MATERIALS

Canvas Size: 12 x 16–inch (30 x 40–cm) canvas
Paint Colors: Prussian Blue, Indigo, Titanium White, Green Earth
Medium: Walnut Alkyd Oil (speeds up drying time) or walnut oil (slows down drying time)

BEFORE YOU BEGIN

This painting has a very simple composition. We are going to be placing our horizon on the bottom-thirds line, and then using the brushwork for our clouds to practice pulling the eye down toward our focal point on the left side of the horizon.

Because of the blending techniques we use for this painting, I recommend giving yourself enough time to work through all the steps in one sitting, if you are able. It will be great practice for learning how to paint wet on wet, and it will really help you get comfortable with blending techniques.

THE PROCESS

1. Using a ruler and a pencil, establish your horizon line on the bottom-thirds line of your canvas.

2. Pick up your size 24 blending brush and mix together a tiny amount of Indigo, Prussian Blue and Titanium White on your palette. Make sure to only add a small amount of medium so that the color doesn't get too thin. You want a nice deep blue for establishing shadows within the painting.

 Begin transferring that color onto your canvas in areas where the bottom of the clouds might sit. You should be using a lot of pressure on your brush and moving it in small circular motions to transfer the paint from the brush onto the canvas. Try to practice applying minimal amounts of paint to your canvas, and then use a firm brush pressure to spread it around in thin layers.

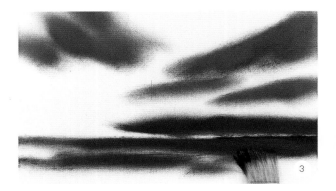

3

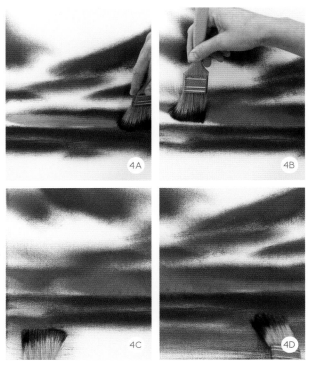

3. Now that you have finished blocking in the cloud shadows on your canvas, it's time to begin blocking in the ocean below. With the same brush you were just using, add a little bit of Green Earth to the shadow color that is on your palette. Begin applying that color to the bottom section of your canvas, going back and forth with horizontal brushstrokes. Anytime you want to paint water in a landscape, remember to move your brush along the canvas in the same direction that the water would rest in the natural world.

4. Add a little bit of Titanium White to that same brush and transfer the slightly lighter color into the sky directly above the horizon line.

 Another great way to remove the excess paint from your brush is to move it back and forth in a section of color that could use some of that color in a later step. In this instance, the bottom of the canvas could use a little bit more of that blue, so this is the perfect place to clean off your brush!

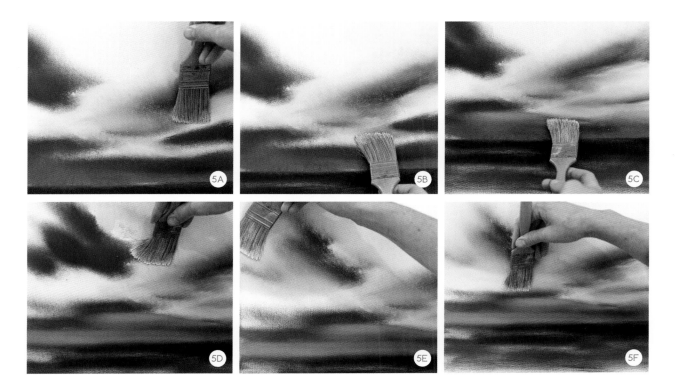

5. The next step for this painting will be to begin blocking in the highlights of our clouds. With a fresh blending brush (or wipe off well the one you are using), pick up some Titanium White from your palette and begin filling in the blank sections of your sky with this color.

You want to use a lot of pressure on your brush and very small circular motions for this step. These small circular motions serve two purposes in this stage of the painting process. First, they help transfer a thin and even coat of white paint into the sections that need to be covered. Second, they gently pull hints of the shadow color into the area that is being blended, creating some interesting depth to the clouds.

You want to imagine that your brush is mimicking the way that the clouds are floating within the sky you are creating. By moving your brush from left to right in a straight line, the clouds will appear to be floating along the horizon line. By pulling your brush from the center of your canvas up towards one of the corners, you are making the clouds appear to be more windswept and in motion. These techniques will also really help you create a scene that pulls the eye towards the focal point. It is so much fun exploring what these brush movements can create within a cloudy scene, so be sure to experiment and see what your brush movements can create in this step of the process.

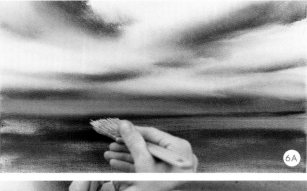

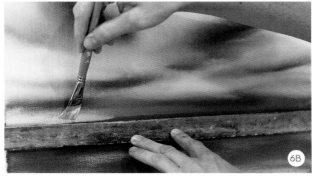

6. Once you are happy with how your sky is beginning to feel, transfer some of the lighter color that is on your brush to just below the horizon line—into the water. This line is going to act as part of the reflection of the sky in your scene.

If you're anything like me and you've completely lost your horizon line because of all the different blending work we have done, use a ruler to re-establish your horizon along the bottom thirds line of your canvas once again. Using the straight edge as a guide, add some white paint to your brush and then pull that light color all the way along the ruler until you have crossed the entire canvas. Remove the ruler from your canvas and wipe off the excess paint from the brush that you are using. Then take that brush and gently drag it along the horizon line from one side to the other two to three times to soften any harsh edges that were left from the ruler.

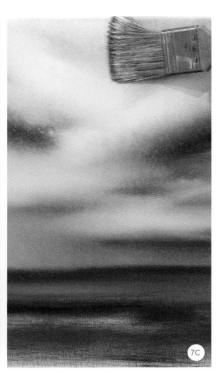

7. Pick up a rag or paper towel and wipe off all the excess paint from one of your blending brushes. On your palette, mix a small amount of Titanium White and a very small amount of Green Earth together. A fun way to create a break within the clouds that are floating along the horizon is to make it look as though a pocket of light rain is coming from one of those clouds. This is a very simple look to achieve, and all you need to do is take your brush and place it anywhere on the cloud line where you would like to add a little rainfall. With a medium amount of pressure and small circular motions, transfer that nice light color into the area you have chosen. Then with the same pressure and circular motion, move your brush down to the horizon line stopping right at the water's edge. You can repeat this action two to three times and make the rainy section as small or big as you like!

Without cleaning off your brush, apply some of the color that is on it gently into the clouds above your rainy section as seen in the photos. Use gentle circular motions and very light pressure to really soften the edges on a few of the clouds in this area and see how it transforms the look and feel of your painting. If you accidentally do too much blending and you lose too much cloud definition, that's completely ok. Just pick up one of your smaller blending brushes and re-establish the highlights and shadows of that cloud once again.

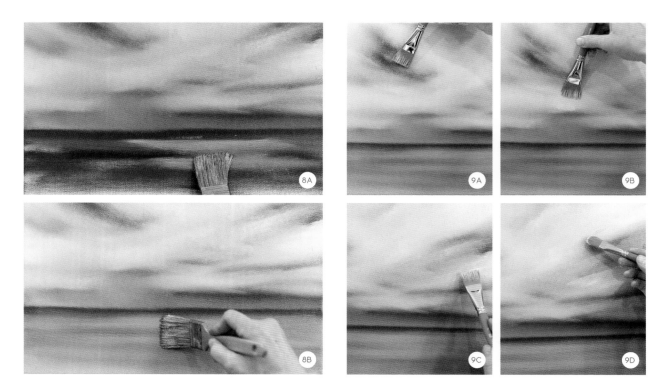

8. Pick up the blending brush that you were using in the previous step and, without cleaning it off, begin transferring that color into the area of the water reflection. Moving your brush back and forth from left to right with lots of pressure, make sure that there is no more blank canvas showing in this bottom section of the canvas.

 It is now time to smooth out the water's reflection. Without cleaning off your brush and using lots of pressure, drag your brush from left to right across the canvas just below the horizon line. At the end of each pass, move your brush down the canvas half of a brush width and then repeat the same steps until you reach the bottom of your canvas. When you are finished, your water should look very flat and very still.

9. Now we get to add the final highlights to our beautiful cloudy scene. You can use any of your smaller blending brushes—just make sure that you wipe off all the excess paint from them first. One of my favorite ways to add interesting highlights to clouds within a skyline is to hold my brush at the same angle as the clouds I am working near, and to just gently tap or jiggle the brush along the canvas for a few inches or so, transferring some of the white paint that's on my brush into the area. I like to leave these little cloud wisps as they are and not blend them in, because I find that they add a little bit of magic to the overall scene.

 Using only Titanium White and with very soft circular motions, gently transfer this white into the top half section of the clouds within your scene. This will create the final highlight for your clouds

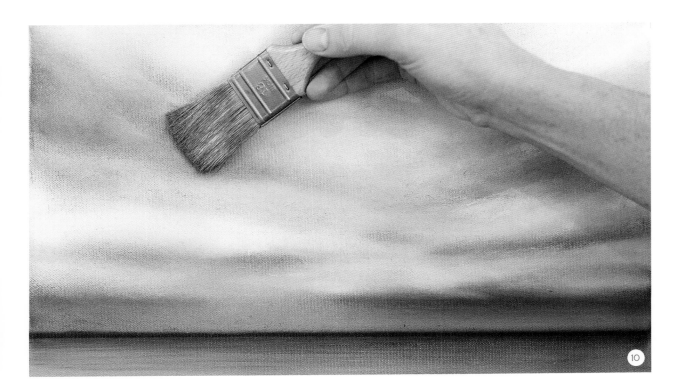

and will really give them a three-dimensional effect. Experiment with what happens when you add only a little bit of white to the top section of a cloud and when you add a fair bit of white to the top section of a cloud. When you stand back from your canvas, you can see how different of an effect each option creates.

10. Finally, let's gently soften harsh shadows that may stand out within your painting. If you find that a section of your sky feels a little too dark, just take your larger blending brush and wipe it off completely on a rag or paper towel. Take this blending brush and, with barely any pressure on it at all and with small circular motions, gently go over any areas that feel a little too dark within your skyline. This is very subtle brushwork and you will not need to do very much of it.

11. These final stages take a lot of playing around to get just right. Be sure to have fun with this section and really explore the subtle nuances between the shadows and highlights as you put the final touches on this beautiful painting.

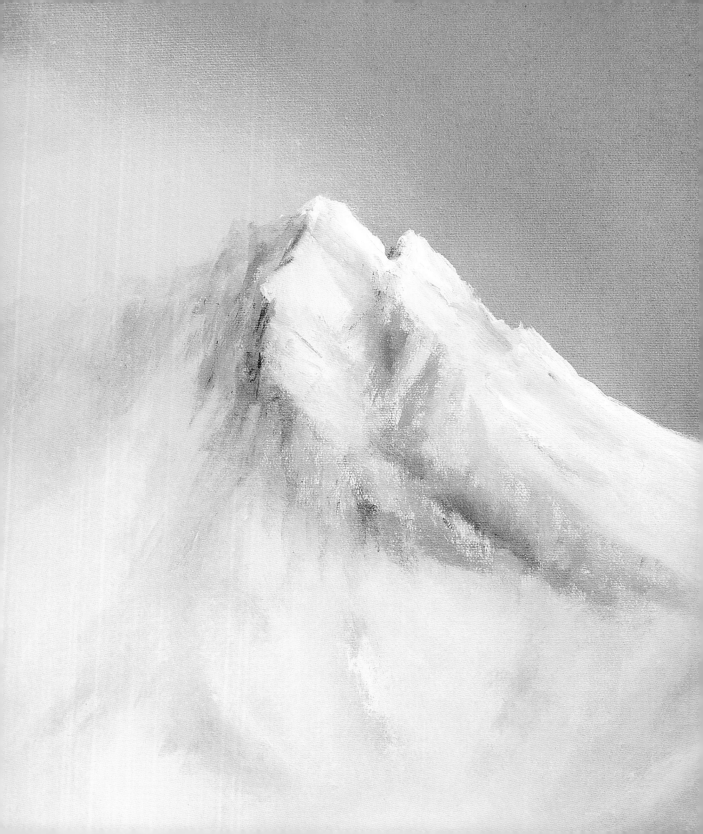

WISPY MOUNTAIN PEAK

There's something so serene and peaceful about snow-covered mountains. I love capturing their majestic, ancient beauty with my brushes, and creating the feeling of bitter wind racing across snow-covered slopes.

In this 11 x 14–inch (28 x 35–cm) painting, I am going to walk you through how to build up various layers of shadows and highlights so that a realistic mountain peak begins to form on the canvas in front of you. This painting will provide a wonderful opportunity to really practice creating different angles and shapes with your brushes, and to see how the sections really play off one another in the final piece.

MATERIALS

Canvas Size: 11 x 14–inch (28 x 35–cm) canvas
Paint Colors: Titanium White, Charcoal Grey, Cerulean Blue
Medium: Walnut Alkyd Oil (speeds up drying time) or walnut oil (slows down drying time)

BEFORE YOU BEGIN

The composition of this piece will follow the rule of thirds, with the focal point resting around the upper left section where the wind has whipped up some snow into the sky.

You can do this whole painting using the wet-on-wet technique, or you can stop and let it dry at any stage you'd like!

As you work through this painting, be sure not to wash your brushes in between any of the steps. If you only have a few brushes on hand and need to reuse them, just wipe your brush back and forth on a rag or paper towel repeatedly until all of the excess paint comes off.

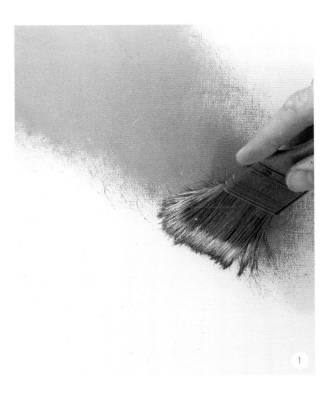

THE PROCESS

1. Pick up your size 24 blending brush and mix together some Cerulean Blue with a very small amount of Charcoal Grey on your palette. Add a tiny bit of Titanium White to slightly soften the color and a few drops of medium to slightly thin out the consistency. Begin transferring this color onto your canvas using a lot of pressure on your brush and large circular motions. You want a nice thin layer of paint to cover the sky portion of your painting, but try not to bring this color too far down your canvas at this stage. We want the mountain peak to remain really light and soft, and we don't want this color to overpower our highlighted sections.

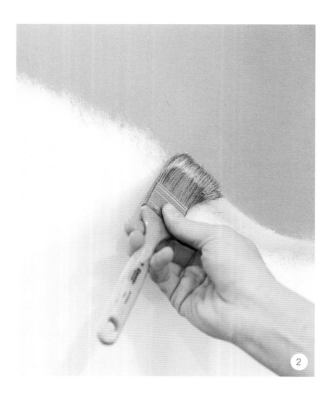

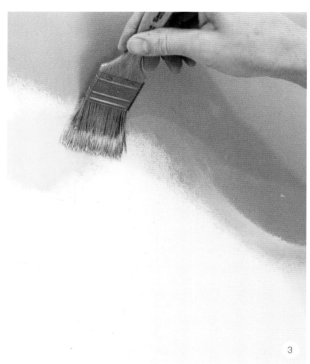

2. Add some Titanium White to the same brush you were just using and begin to establish where it is that you want your mountain peak to sit within your painting.

3. Using the same brush, soften the area directly to the left of where the highest point of your peak is going to sit. This is the first layer for making it look as though a cold wind is blowing across the mountain peak and lifting snow into the sky.

4. Next, we need to establish where we want our rock formations and shadows to sit on this mountain peak. Using the same brush as before, begin transferring the color that's on your brush into the areas where there will be some shadows on your mountain.

5. It's important to imagine where your light source is coming from whenever you are laying out your shadow areas. In this painting, the light is coming from the righthand side of the canvas, and it's shining from the top corner down onto this mountain peak. Everything that is not being hit by the sun is going to have a shadow color beneath it, so try to keep this in mind as you're blocking in your shadows. Understanding and seeing all these subtle nuances takes a lot of time and practice, so don't worry if it's a little confusing right now. Just follow my lead, and you'll begin to see what I mean as your paintings begin to take more shape.

6. Using the same brush, add a small amount of Charcoal Grey to the bristles and block in some more shadows on your mountain.

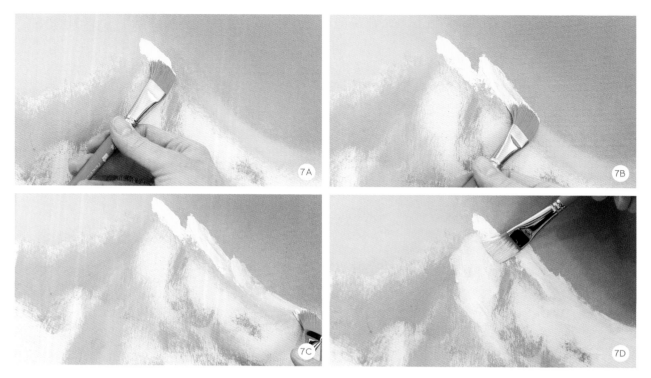

7. Using a fresh 1- or ¾-inch (2.5- or 2-cm) blend-
 ing brush, pick up some Titanium White and begin
 blocking in the brightest spots on the mountain
 peaks. Do not add any medium to your paint from
 here on out. You want the consistency to be a
 little thicker and harder to move across the
 canvas so that all of the different shapes you
 create don't muddy one another.

8. Try to jiggle your brush a little bit as you move it
 along the canvas in this section. The subtle bumps
 and edges that this technique creates will really
 add some pleasing dimension to your snowy slopes.

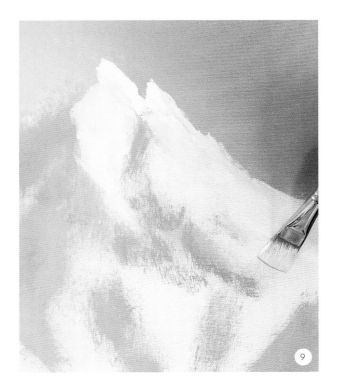

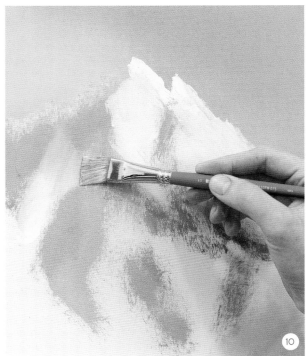

9. Add a little bit more Titanium White to your brush and begin filling in the blank sections of the canvas that have no paint on them yet. Try not to blend this soft color into the shadows that you have already established; just block in the lighter sections with it instead.

10. One of my favorite parts of working on mountain paintings is beginning to blend the transition lines to really start creating depth and dimension within the scene. With barely any pressure on your brush, begin softening some of the transition lines between the white paint that you just blocked in and the shadows that you already have on the canvas. By gently moving your 1-inch (2.5-cm)

blending brush back and forth along the transition line between light and shadow, you begin creating a three-dimensional look to your painting.

With a gentle amount of pressure on your brush, keep working it throughout the different sections and gently pull some of the shadow color down towards the bottom of the canvas.

11. An important tip to follow with your brushwork in this stage is to only move your brush in the direction that the snow would naturally sit within the painting. Match the angle of the slope with the angle of your brush and move your brush along the same plane to blend or transfer colors into that area.

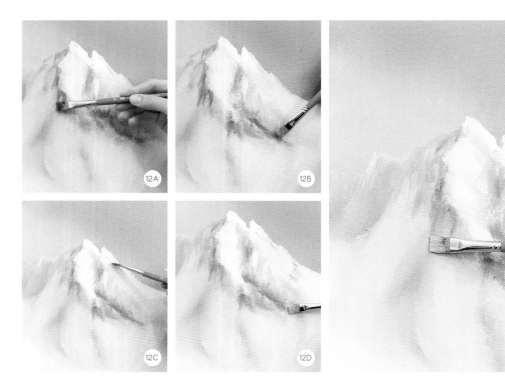

12. Now it's time to begin adding a little more definition to some of the shadow areas of your painting. Wipe off the 1-inch (2.5-cm) brush you were using, and add a little bit of Charcoal Grey to it from your palette. Use this brush to start establishing where the darkest rocks are on this mountain face. These are subtle brushstrokes where you just want to leave a hint of the color in a certain space, but it is truly amazing how they can transform the scene in front of you quite quickly.

13. As you play around with the different brushstrokes that are shown in these images, be sure to put your brushes down from time to time, and to walk away from your canvas to give your eyes a break. It's easy to lose track of shape and form as you're sitting really close to an image; by stepping away for occasional breaks, you allow yourself to see the scene with fresh eyes and to make adjustments that you might have otherwise missed.

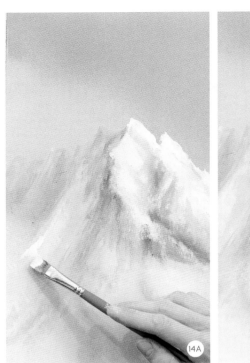
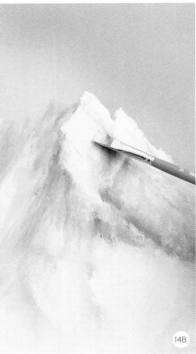
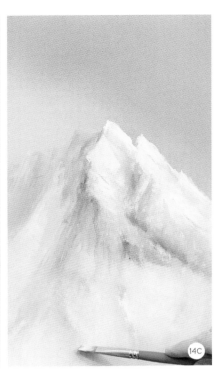

14. The final step of this painting is to wipe off your 1-inch (2.5-cm) brush and add some Titanium White to the areas that you really want to highlight in your mountain scene. The easiest way to achieve these highlights is to take the tip of your brush and softly pull it along the planes of the mountain face that would be closest to the light source.

By adding a small line of white along the snow-covered peaks and along the top of some rocky outcrops, you will create a three-dimensional effect that looks very realistic within your scene.

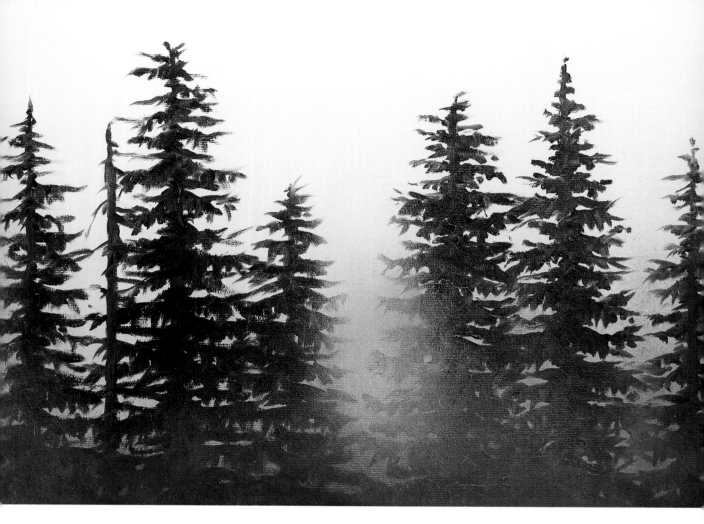

OLD GROWTH FOREST

My heart and soul belong to the depths of a West Coast forest, and bringing these ancient sleeping giants to life with my brushes has become a great passion of mine.

In this 12 x 16–inch (30 x 40–cm) painting, I am going to walk you through how to blend a perfect misty background, how to create realistic-looking trees and how to pull mist through those trees and into the foreground.

Canvas Size: 12 x 16–inch (30 x 40–cm) canvas
Paint Colors: Titanium White, Green Earth, Indigo, Charcoal Grey
Medium: Walnut Alkyd Oil (speeds up drying time) or walnut oil (slows down drying time)

BEFORE YOU BEGIN

As you work through this painting, be sure not to wash your brushes in between any of the steps. If you only have a few brushes on hand and need to reuse them, just wipe them back and forth onto a rag or paper towel repeatedly, until all the excess paint comes off.

The reason why you do not want to wash the brushes as you are working through this painting is because the brushes will hold whatever cleaning solution that you use within their bristles, which will thin out the paint and make the blending work very challenging.

THE PROCESS

1. With your size 24 blending brush, mix together a tiny amount of Indigo, Green Earth, Charcoal Grey and Titanium White on your palette. You want to create a really soft blue-gray color. Be sure to only add a small amount of medium to this mixture as we do not want the paint to be too thin.

2. With a lot of pressure on your brush, move it along in circular motions, covering the entire bottom half of the canvas with the color you created.

3. Using the same brush, mix in some Titanium White on your palette so you have a slightly lighter color, and block in the middle section of the canvas with it. Use a lot of pressure on your brush and large circular motions to spread a thin layer of paint through this midsection.

4. With your blending brush, pick up some Titanium White and transfer it onto the top section of your painting with circular brushstrokes.

5. Wipe off any excess paint from your blending brush onto a rag or paper towel, then begin working your brush along the transition lines of your background.

 What you are trying to do is soften the background to make it look as though it goes from dark to light without showing any harsh edges or brushstrokes. This technique takes a bit of practice to perfect, so be sure to take your time and really play around with this on your canvas.

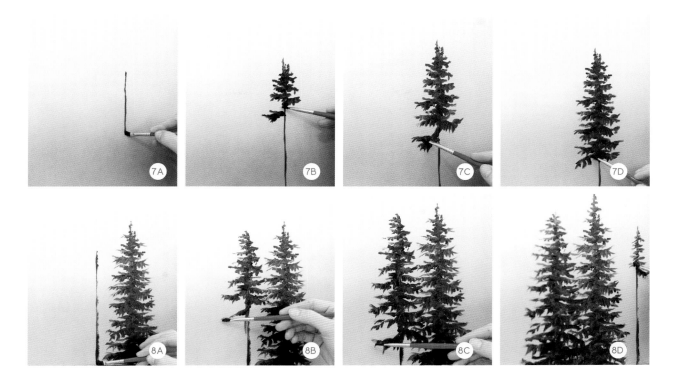

6. Once you are happy with how your background feels, pick up one of your smaller detail brushes and mix together Green Earth, Indigo and a tiny bit of Charcoal Grey on your palette. You want this color to be more green than blue, so make sure that green is your prominent mixing color. Do not add any medium to this mixture.

7. Begin adding trees to the foreground of your painting (see Painting Evergreen Trees, page 20). Try not to have any of your treetops go above the top-thirds line on your canvas because it distracts the eye from the focal point of your painting, and makes the scene feel off-balance.

8. When it comes to creating a realistic tree line in a painting, you really want to focus on making each tree look unique. That means trying different shapes with your branches, creating different tree heights, adding different spaces in between your trees (even if it's very subtle) and adding in dead, standing trees that will really make the forest look realistic.

9. Make sure to hold your brush very softly in your fingertips and to allow it to roll across your fingertips very loosely when creating branches. If you are too tense when you hold your brush, you are more apt to create lines that don't really exist on trees in nature. Since nature is imperfect and all of those imperfections are what create natural beauty, you really want your brush to be loose and free in your hand as you work through this scene.

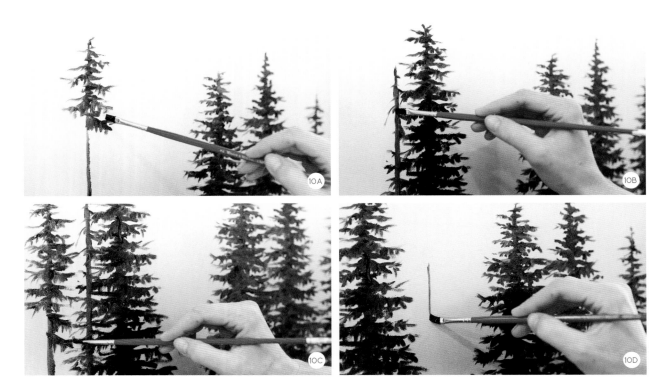

10. Continue building trees along the foreground of your painting, putting them wherever you feel they need to sit. There is no right way or wrong way to create a forest, so be sure to have some fun and allow your imagination to wander as you get creative in planting your trees.

11. After you've blocked all of your trees and you're happy with how it looks, allow your painting to fully dry so that we can add the final layer of mist.

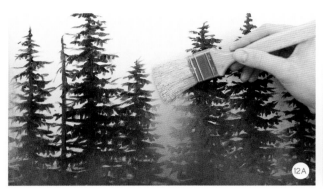 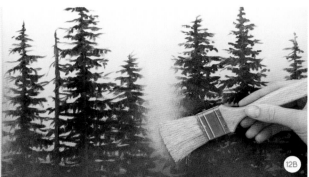

12. Once your painting has fully dried and no paint transfers onto your hand when you run it across the surface, you are ready to create the soft pocket of mist rolling into the foreground.

Add some Titanium White to a clean, size 24 blending brush, and wipe off most the excess paint that is on the bristles. You do not want much paint on your brush for this step. In the midsection of your painting, near the tops of the trees, begin moving your brush in a soft circular motion with a gentle amount of pressure. Work your brush from that section down toward the bottom of your canvas, creating a pocket of mist wherever you feel it should sit within your landscape.

You barely need any pressure on your brush to create this effect. If you find that you've added too much paint and your mist is not very soft-looking, just take a rag or paper towel and gently remove some of the paint from that area.

This technique is a lot of fun to play around with, and I encourage you to see what kind of misty magic you can create with this new little skill.

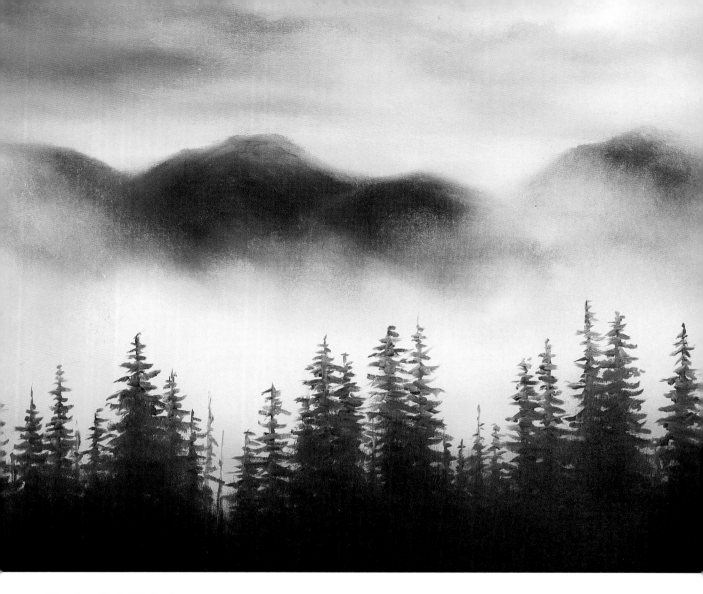

PACIFIC NORTHWEST SCENE

If you have ever been to the Pacific Northwest, you surely saw many beautiful landscapes such as this. Capturing the beauty of misty mountain ranges and old-growth forests has become quite a passion of

mine, and I am excited to walk you through this moody West Coast painting from start to finish.

In this 20 x 24–inch (50 x 60–cm) painting, I am going to show you how to break this scene down into manageable sections using all of the techniques that you have learned so far in this book. You can stop at any point you would like to let the painting dry before moving on, or you can paint the whole piece using the wet-on-wet technique.

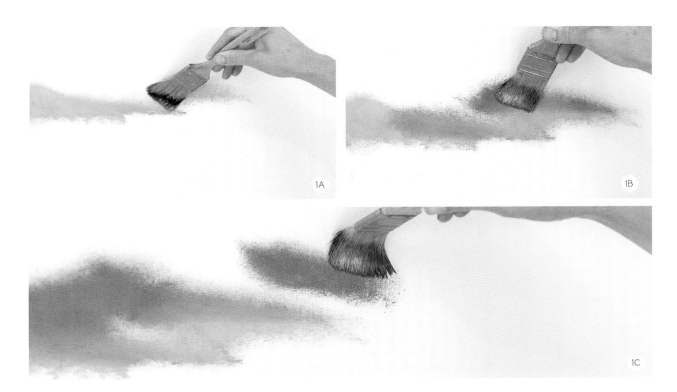

MATERIALS

Canvas Size: 20 x 24–inch (50 x 60–cm) canvas
Paint Colors: Titanium White, Charcoal Grey, Indigo, Cerulean Blue, Green Earth
Medium: Walnut Alkyd Oil (speeds up drying time) or walnut oil (slows down drying time)

BEFORE YOU BEGIN

We are following the rule of thirds for the composition of this painting. The mountain ridge rests along the top-thirds line, the treetops all meet near the bottom-thirds line, and there is a bright pocket of mist behind the trees that draws the eye to the focal point in the bottom lefthand corner of the painting.

As you work through this painting, be sure not to wash your brushes in between any of the steps. If you only have a few brushes on hand and need to reuse them, just wipe your brush back and forth onto a rag or paper towel repeatedly until all the excess paint comes off.

THE PROCESS

1. The first step of this painting will be blocking in the cloudy sky in the top third section of the canvas. With your size 24 blending brush, mix together some Cerulean Blue and a small amount of Indigo together on your palette. Soften this color slightly by adding a tiny bit of Titanium White. Make sure to only add only a few drops of medium so the paint doesn't become too thin.

 Using a lot of pressure on your brush, begin transferring this soft blue color into the lefthand side of your sky. This color is going to be the shadow base for your clouds, so move your brush along the canvas in the same direction that you want your clouds to sit within the scene.

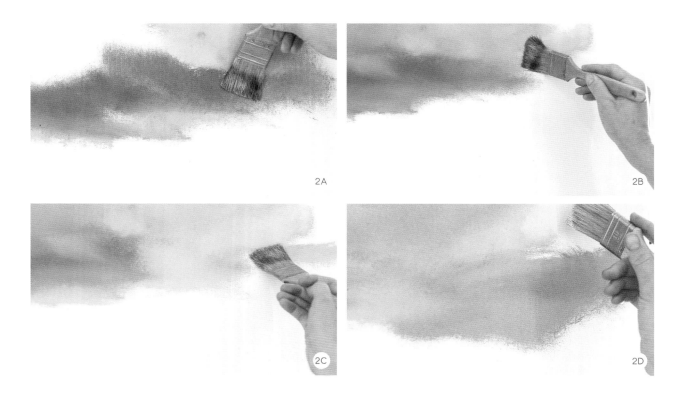

2A

2B

2C

2D

2. Once you've blocked in the layers of shadows on the left, add some Titanium White to the same brush (without cleaning if off) and begin filling in the righthand side of the sky using the same brush techniques. It's okay if different shades of the color transfer into your sky at this stage; it will make for really interesting cloud layers when we add some highlights.

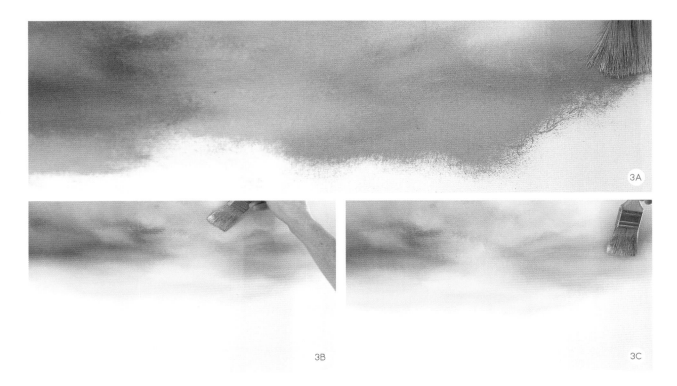

3A

3B

3C

3. We are now going to add a little bit of Charcoal Grey to the bottom of the sky on the righthand side of the canvas. Using a gentle amount of pressure, transfer a little bit of this color into the shadow areas. This subtle change in color temperature from left to right within the sky is really going to make the painting look realistic.

 Take time in this section to really play around with the shadow and light within your clouds. Subtle brushwork can really transform how your sky feels! Make sure you step back from your painting every once in a while to see if it's feeling balanced, as well.

 This is a wonderful place to stop and to allow your painting to fully dry if you do not want to complete it all in one sitting.

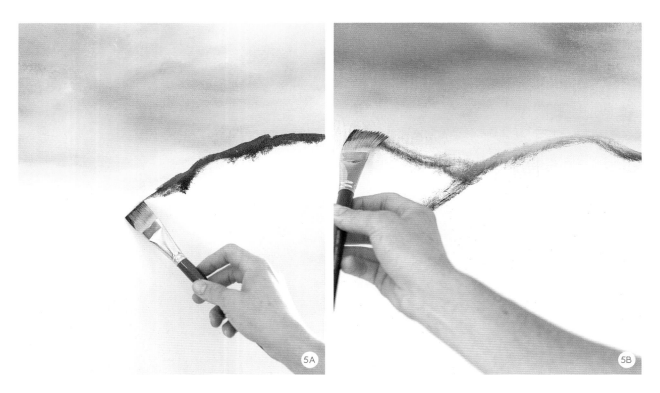

4. Once you're happy with how your sky looks, we now get to build up our mountain range that's resting right beneath these clouds. Using a 1-inch (2.5-cm) brush, mix together Charcoal Grey and tiny bits of Indigo, Green Earth and Cerulean Blue. You want a nice deep blue-gray color on your palette. You might need to add a little bit of medium to this so it can move easily across your canvas.

5. Use this dark color to trace the outline of where you want your three mountain tops to sit within your scene. You should have them rest slightly above and below the top-thirds line.

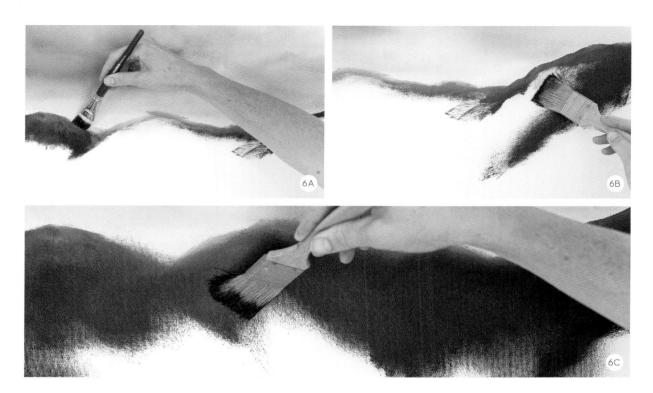

6. Using the same 1-inch (2.5-cm) blending brush or one of your larger blending brushes, begin blocking in the remaining parts of the mountain section with this dark color.

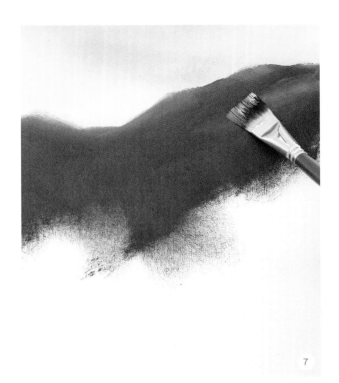
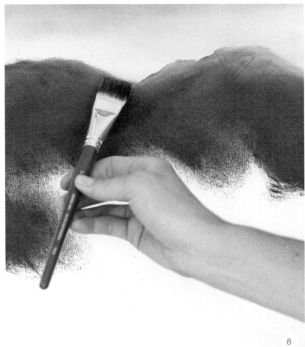

7

8

7. To add a little definition to the mountain range, take your 1-inch (2.5-cm) brush and add a tiny bit of Titanium White to it. Gently add in some soft lines to make it look like there are various ridges on this little mountain range.

8. You can also take a little bit of the sky color that you used from your palette and transfer it onto the tops of the mountains to make them look a little softer against the skyline.

 The next stage to this moody West Coast scene will be to block in the misty layer that sits at the base of the mountain and behind the trees. This misty section is very important, as it will become our focal point within this scene.

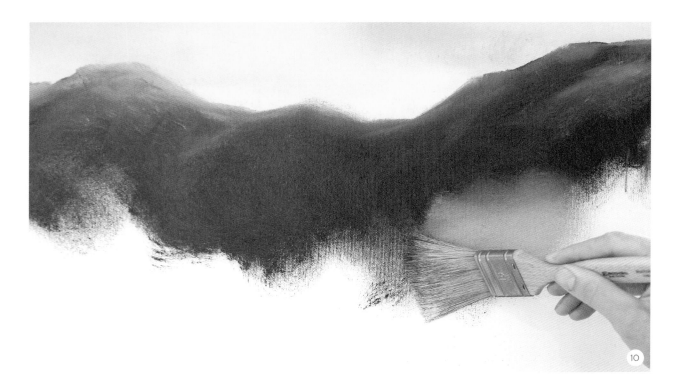

9. Wipe off your size 24 blending brush on a rag or paper towel, and mix Titanium White with a little bit of Charcoal Grey and Green Earth on your palette. The reason why we are adding some green to the color is because there's going to be an entire layer of green trees in the foreground, and we want our mist have a slight reflection of that color within it.

10. With a lot of pressure on your brush and using circular motions, begin transferring this color into the area that is slightly above the bottom-thirds line in your painting. If your brush picks up too much of the mountain color while you do this, just wipe it off on a rag or paper towel and add a bit more Titanium White to the section you are working on. Keep blending this area until you are happy with how your mist is beginning to look.

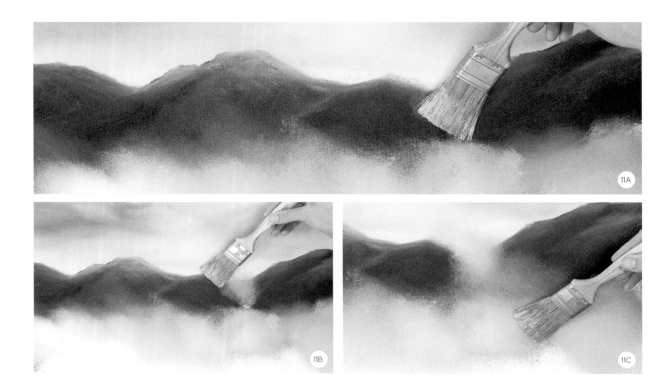

11. Using the brush that you used to block in the mist, add some Titanium White and create a little valley in the center of your mountain range. With a lot of pressure on your brush and small circular motions, transfer some of the white paint into this new section. Without lifting your brush and with a minimal amount of pressure, begin softening the section of white that you just added. This is a fun trick to use for creating the illusion that mist is rolling over the mountain ridge.

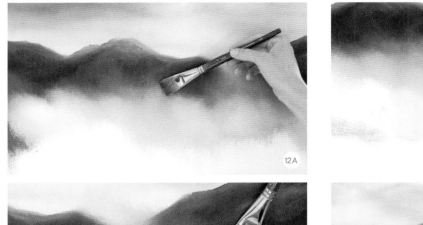

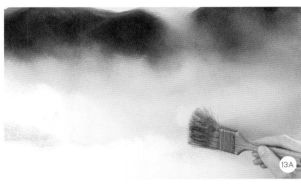

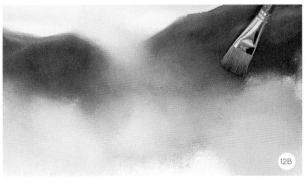

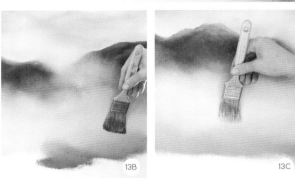

12. After you're happy with how your mist looks in that section, pick up your 1-inch (2.5-cm) brush and wipe off any excess paint that may be on it. Use this brush to begin softening the transition between the dark mountain color and the light mist color, using gentle circular motions. This is very subtle brush work; you do not need a lot of pressure on your brush for it to really begin creating a three-dimensional look to the edges of your mist.

13. Using your larger blending brush, add a little bit of Charcoal Grey and then transfer that color into the base of your mist section using circular brushstrokes and a lot of pressure. Work this color right down to the bottom of your canvas so that there is a seamless layer of mist in this area. Once you are happy with how this section feels and there is no more blank canvas showing, it is time to move onto the final section of this beautiful painting.

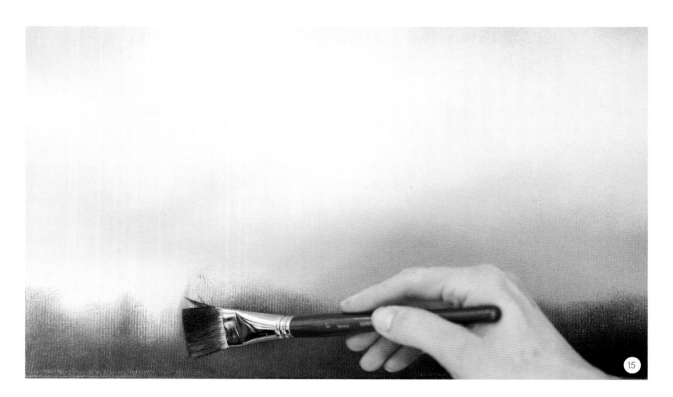

14. Using your 1-inch (2.5-cm) brush, mix together Green Earth, a tiny bit of Charcoal Grey and a very little bit of Indigo. This is going to be the main tree color for the foreground, and we are going to begin by blocking in where the base of the trees will be sitting along the bottom of the canvas.

15. Take your brush and transfer this color along the very bottom section of your canvas, gently blending it up about 2 inches (5 cm) or so into the misty area. This will provide a nice base onto which you can paint your trees.

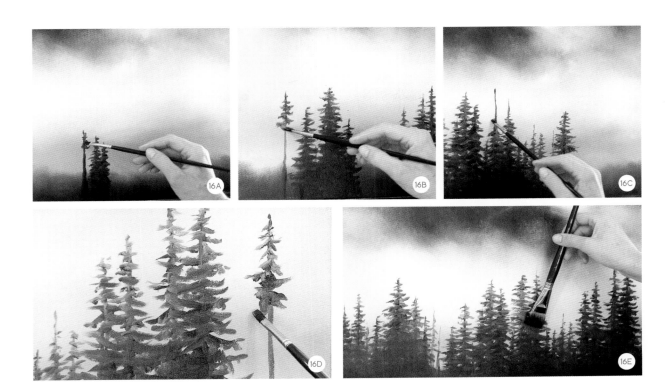

16. Take a smaller detail brush and dip it into the dark tree color you created. Begin creating the line of trees that will make up the foreground of your painting. Remember to make the trees different heights and different shapes, and to add a dead, standing tree or two in there as well. You want the tips of your tallest trees to go no higher than the bottom-thirds line of your canvas if you can help it. Take your time and have some fun with these final brushstrokes!

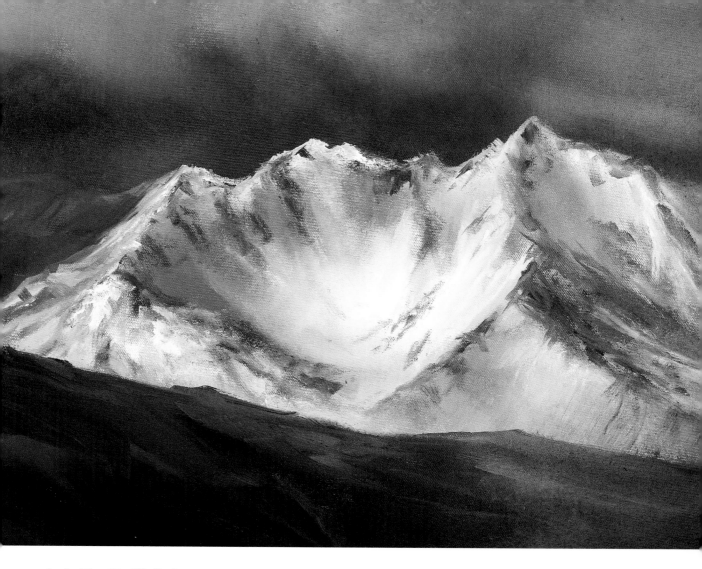

MOODY MOUNTAIN RANGE

There is something truly arresting about a dark sky silhouetting a moody mountain range, and in this 14 x 18–inch (35 x 45–cm) painting, I am going to show you how I achieve this dramatic look through simple brushwork and easy-to-follow steps.

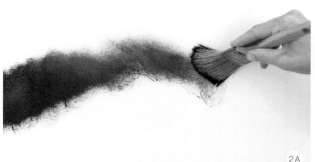

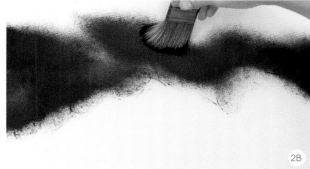

2A

2B

BEFORE YOU BEGIN

The composition of this painting follows the rule of thirds, with the mountain ridge sitting along the top-thirds line and the bottom rock face resting near the bottom-thirds line. To balance it all out nicely, the focal point rests just left of center, where the highlights are most pronounced. The bold colors and bright highlights really make quite the statement in this painting as well.

You can do this whole painting using the wet-on-wet technique, or you can stop and let it dry at any stage that you'd like.

As you work through this painting, be sure not to wash your brushes in between any of the steps. If you only have a few brushes on hand and need to reuse them, just wipe your brush back and forth onto a rag or paper towel repeatedly, until all the excess paint comes off.

THE PROCESS

1. With your size 24 blending brush, mix together some Indigo and Prussian Blue on your palette, adding a tiny bit of medium to thin it out ever so slightly. You do not want your paint to be too thin, as you want to be able to build clouds on top of this dark color, so make sure that you only add a few drops of medium.

2. With a lot of pressure on your brush and large circular motions, transfer this rich color into the sky area, and rough in where the mountain peaks are going to sit as you do so. You don't want to pull this color too far down your canvas, as it will overpower the highlights, so try and keep it in the upper section only. Leave 1 to 2 inches (2.5 to 5 cm) of blank canvas at the top for the next step.

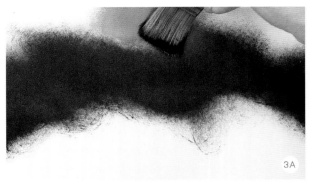

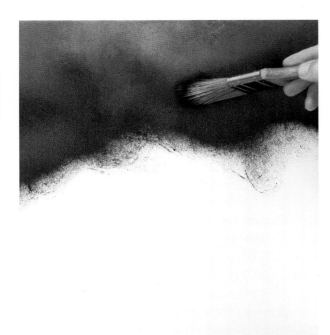

3A

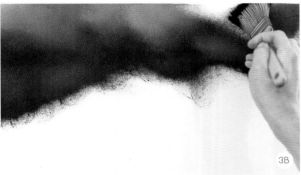

3B

4

3. With the same blending brush, add a little bit of Titanium White and begin filling in the top section of your canvas that does not have any paint on it. Using circular motions and a lot of pressure on your brush, begin transferring this lighter color into the top area.

4. With a rag or paper towel, remove any excess paint from the brush that you were just using. Then, with a very gentle amount of pressure and small circular motions, gently blend the transition lines where the light color meets the shadow color to soften the edges and begin creating a more realistic look to your clouds. Take your time and really explore what different brushstrokes do to change the feel of your painting. You can add more shadows or more highlights if you feel they are needed. Have some fun exploring these cloud-building techniques!

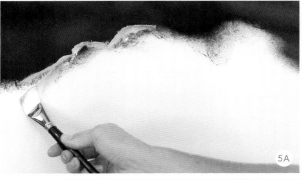

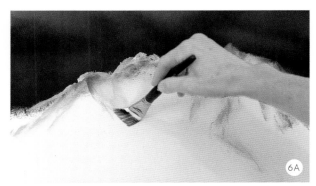

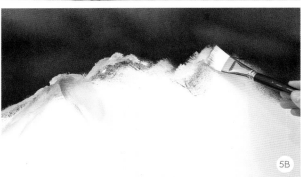

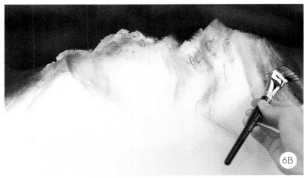

5. Once you're happy with how the sky looks, pick up your 1- or ¾-inch (2.5- or 2-cm) brush, and add some Titanium White and a tiny bit of medium to it. Now you will establish where you want your mountain ridge to sit within your painting. I have mine resting slightly above and slightly below the top-thirds line.

6. Once you determine where the ridge is going to sit, begin pulling some of the color that's on your brush down toward the bottom of the canvas until it fades out. These lines that you create are going to be the beginning of the shadow work for the mountain face.

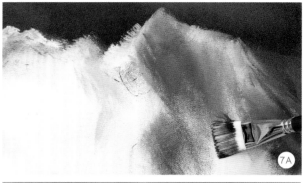

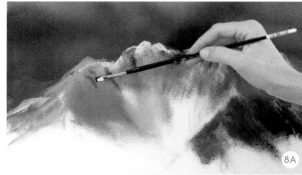

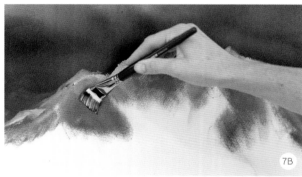

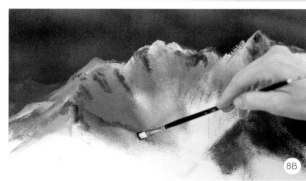

7. Using the same brush, add some Charcoal Grey and Indigo to a section of your palette and mix it together. Begin transferring that color onto the canvas, pulling it down from the peaks to create the illusion that there's a shadow resting there. When you paint mountains, you really want your brush to move in a way that mimics the shape of the mountain itself.

8. With one of your smaller detail brushes, pick up a tiny bit of Charcoal Grey and begin roughing in where some rocks might jut out of the snow within your scene. You want subtle hints of them showing through the snow, so play around with where you feel they should be within your painting.

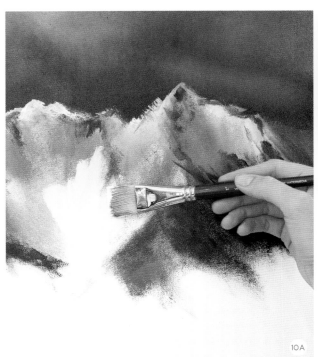

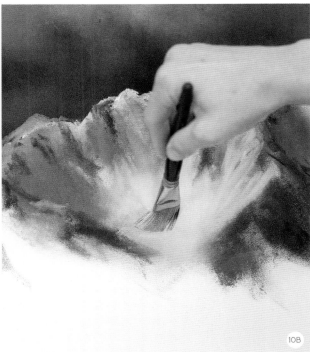

9. The next thing we're going to do is to begin working on the focal point of this painting. At the base of the mountain, just left of center, we are going to create a nice snowy area. We're going to pull each of the surrounding mountain ridges down toward the center of this section by using soft blending techniques and some Titanium White.

10. To begin, take your 1-inch (2.5-cm) blending brush and transfer some Titanium White into the area where you want your focal point to be.

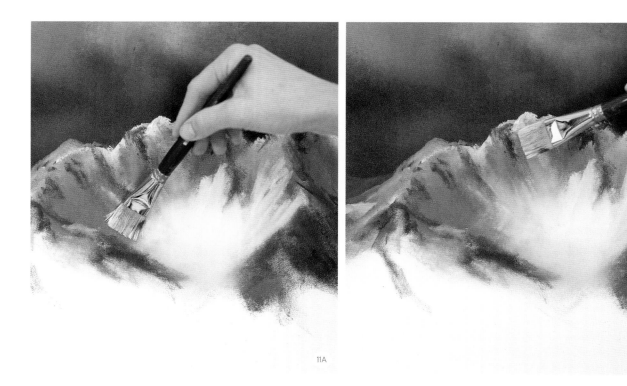

11A 11B

11. After you have blocked in this section with white, gently rub your brush along the transition line where the shadow color meets the white paint you just put down. With a gentle amount of pressure on your brush and with very small angular motions, begin moving your brush up and down the mountain on a diagonal plane, gently softening the shadow transition and the area that you just painted white. You want to focus on spreading the paint up and out toward all the different peaks in your mountain scene.

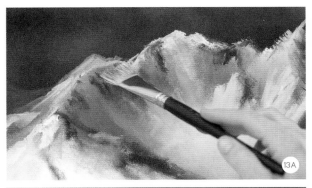

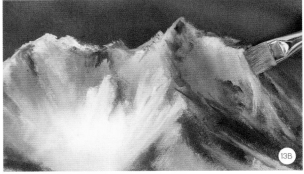

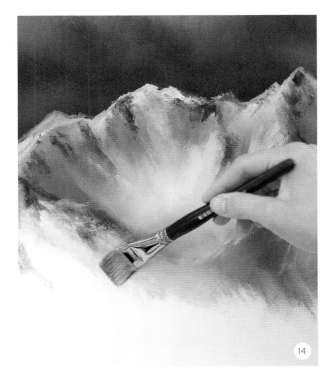

12. Take some time here to play around and see what you can create by moving your brush at different angles and with different amounts of pressure along the canvas. Figuring out the proper amount of pressure to put on your brush in this section might take a bit of practice. The wonderful thing about oil painting, as I mentioned before, is that if you lose any of the shadow color or you have too much white in one section, you can easily correct it by wiping off your canvas or just re-establishing what you need to by going back a few steps in the process.

13. Another brushstroke that will help you create a realistic-looking mountain face is taking your 1-inch (2.5-cm) brush and resting it at the very top of your mountain peak with the flat face fully against the canvas. With barely any pressure, gently allow the brush to come down to the center of the snowy area that you just created.

By doing this, you are creating the illusion of a continuous mountain face, and you are also adding subtle color variations to the highlighted area.

14. Using your 1-inch (2.5-cm) brush, pick up a little bit of Titanium White and finish blocking in the final face of this mountain scene on the left side of your canvas. You want to transfer a nice light color into this section.

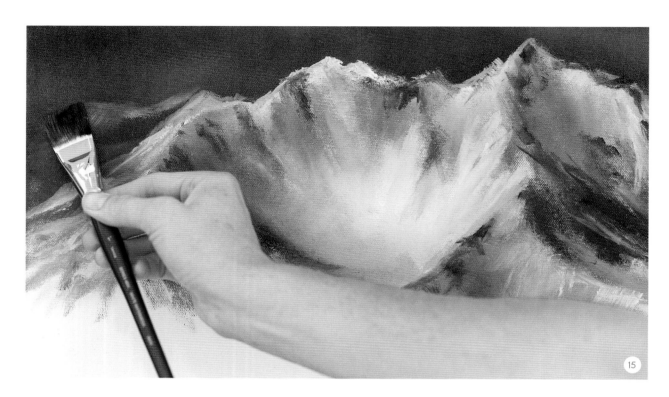

15. After you are happy with your detail work, take your 1-inch (2.5-cm) brush and pick up some of the Grey-Indigo color that you used earlier and add a small amount of Titanium White to it. With the flat face of the brush, gently create a mountain ridge that fades off into the distance on the left side of your painting.

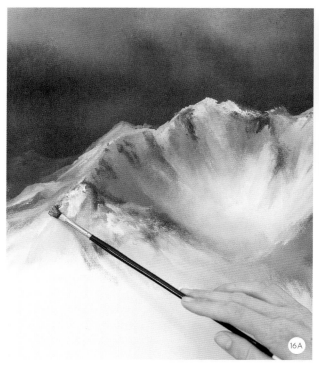 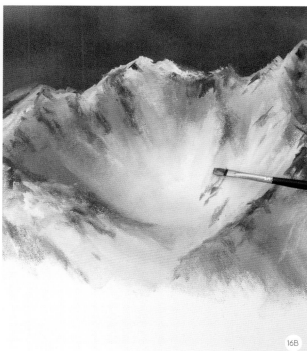

16. After you've finished blocking in that area, pick up your detail brush and add a little bit of Charcoal Grey to it. Use this color to begin defining the subtle rock outcrops that are scattered throughout the mountainside. You can create these rocks by dabbing your brush in any area you want some rocks to sit, or you can gently allow the brush to roll through your fingers in the direction that you want a line of rocks to be within your painting.

17. This is a fun technique to play around with in other areas of the painting as well, because you can easily correct anything that doesn't feel right or balanced by simply using your blending brush to erase it.

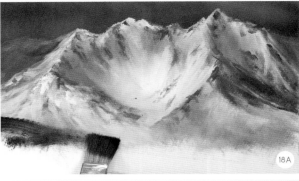

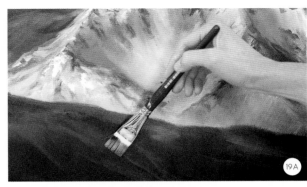

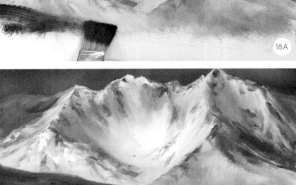

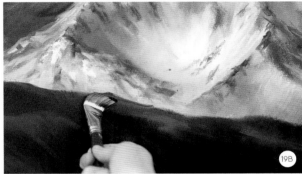

18. Now we get to dive into the final stage of this painting. Pick up your large blending brush and wipe off any excess paint onto a rag or paper towel. Then on your palette, mix Charcoal Grey with tiny bits of Indigo and Prussian Blue. Use this mixed color to establish the top of the rock face that sits diagonally across the foreground of your painting. With a lot of pressure on your brush, fill in the rest of this lower section with this color.

19. After you've blocked in that section, grab your 1-inch (2.5-cm) brush and add a small amount of Titanium White to it. Gently add subtle contour lines on top of the shadow color you just blocked in. You don't need too many of these lines—just enough to make it look like it's rocky.

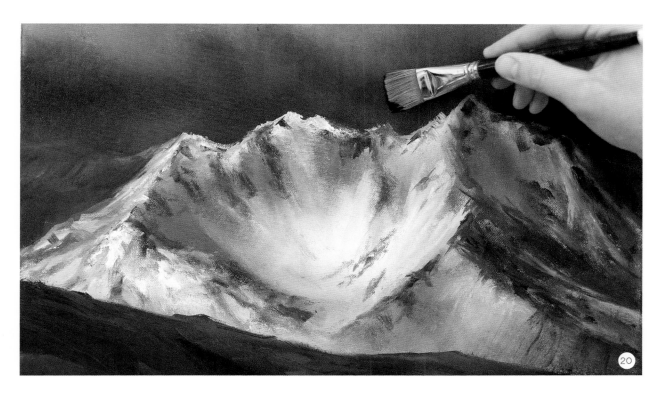

20. The final step to do before you finish this painting is to add a tiny bit more shadow color to the level of clouds that are closest to your mountain ridge. This will really add a nice contrast to that area.

THE MEADOW'S EDGE

I absolutely love the stillness of summer mornings out in the country. Watching the mist settle onto the scenery like a soft blanket is what inspired this next painting I am going to share with you. Sometimes with landscape painting, less is more, and this painting is the perfect example of that.

In this 12 x 16-inch (30 x 40-cm) painting, I am going to walk you through how to create a seamless layer of cool morning mist as it settles over a simple green field, as well as how to layer trees so that they give you the feeling of depth and presence within a scene. As you work through this painting, always keep in mind that objects farther in the distance are lighter and objects closer to the foreground are darker. This is also a great painting to really practice and perfect the blending of transition lines.

MATERIALS

Canvas Size: 12 x 16–inch (30 x 40–cm) canvas
Paint Colors: Titanium White, Green Earth, Charcoal Grey, Indigo
Medium: Walnut Alkyd Oil (speeds up drying time) or walnut oil (slows down drying time)

BEFORE YOU BEGIN

This painting works best if painted all in one sitting using the wet-on-wet technique. If you do need to stop and let it dry, I suggest doing so after you have finished blending the sky and the field.

The composition for this painting is straightforward and follows the rule of thirds. The horizon line rests upon the bottom-thirds line, and the focal point is the stand of trees that draws the eye toward the upper right area of the canvas.

Make sure that you do not use very much medium when you are mixing the different colors for this painting. You want to be able to do lots of subtle blending work within the different layers of this land-scape, and having a thicker consistency to the paint will make the blending much easier for you.

THE PROCESS

1. With your size 24 blending brush, mix together Green Earth, Titanium White and tiny bits of Charcoal Grey and Indigo. You can mix a very small amount of medium into this color as well. Pull this soft green color across your canvas from the left to establish your horizon; it should sit slightly above the bottom-thirds line.

2. Transfer some of this light green color onto your canvas about 2 inches (5 cm) below the horizon line, then wipe the excess paint off of your brush with a rag or paper towel.

3. On your palette, mix some Green Earth with small amounts of Charcoal Grey and Indigo. You really want the green to be very prominent in this mixture. With your larger blending brush, begin blocking in the rest of the field with this nice deep green color. You do not need to pull this color all the way over to the far righthand section of the painting because there will be trees painted in that area.

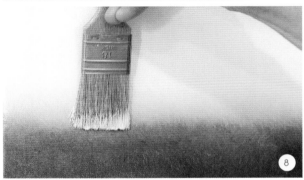

4. Wipe your blending brush well using a rag or paper towel, then mix together a little bit of Charcoal Grey and Indigo with a fair amount of Titanium White on your palette. When you are done, you should have a very light, soft blue-gray color. This is what we're going to use to begin blocking in the misty section of the painting. If you feel that there might be too much paint on your brush, just wipe some of it off onto a rag or paper towel before you begin working on the canvas.

5. Pull this color across the top of your horizon line using circular motions and a lot of pressure on your brush, until the color goes about halfway up into your sky.

6. We are going to be adding white paint to finish the remainder of the sky, but first, we'll work the transition line between the sky and the grassy meadow. I find it very helpful to hold my blending brush so that the handle is near the top of the canvas and the bristles are resting on top of the horizon line for this step. That way I can see what my brush is doing as it is moving across the canvas, and I can adjust my brush pressure accordingly.

7. Now we are going to soften the transition line between the sky and the grassy field in order to give the illusion that the horizon fades off into the distance and doesn't end abruptly with a harsh line of color.

8. Wipe off any excess paint from your blending brush onto a rag or paper towel. With a gentle amount of pressure and working in a circular motion, move your brush across the horizon from right to left so that ½ inch (1 cm) of sky is blending down into ½ inch (1 cm) of the green field. This will really begin to soften the transition line as you do this. You will need to do this a few more times, but make sure you clean off your brush after each pass so that the dark color doesn't get too far up into your skyline.

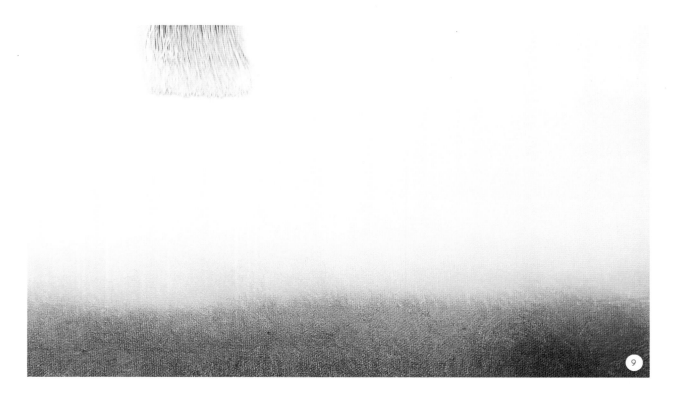

9. Once you're happy with how the transition line looks, add some Titanium White to a clean blending brush and begin blocking in the rest of the sky. When you are finished, your background should be smooth and seamless.

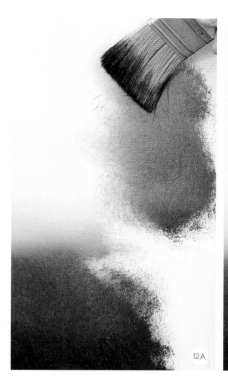

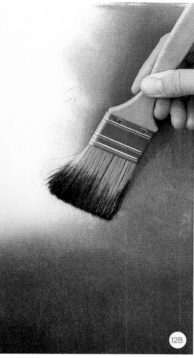

12A

12B

13

10. The next step is blocking in the trees on the right side of the canvas. As you can see in the finished painting, there are three trees layered on top of one another. With every painting you create, you should always remember to work from the background up toward the foreground with your layers. The tree that is farthest in the background will be the first tree we create.

11. Clean off your larger blending brush, then mix together some Green Earth, a tiny bit of Charcoal Grey and a little hint of Titanium White. You want to create a soft green that we will use for the tree farthest in the background.

12. Using the blending brush, begin blocking in the general shape of the first tree. You only want this tree to come out about one third of the way into the sky from the righthand side of your canvas. Use small circular motions with a gentle amount of pressure to really soften the edges of this tree and to give the illusion that it is farther off in the distance and slightly out of focus.

13. Next, pick up one of your smaller brushes and begin adding a little bit of detail to the limbs of the tree that are sticking out into the sky. Make sure you really play with different shapes of branches that might be protruding out from the tree. This does not need to be greatly detailed; just a general shape and silhouette will suffice.

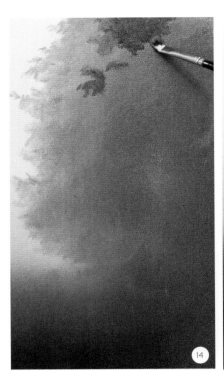
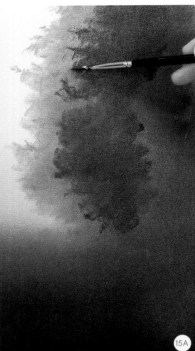
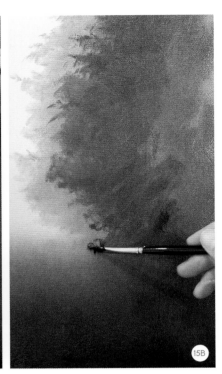

14. Go back to your palette and mix up a slightly darker version of the green that you just used for your first tree. You want to create a medium shade of green for the second tree in this scene.

 Begin creating the outline of your second tree over the top of the tree you just painted. You want to leave at least 1 inch (2.5 cm) of the branches showing from the tree underneath, so don't come all the way out with this tree silhouette.

15. Remember to make the branches on the second tree a bit different than the branches from your first tree. No two trees are the same in nature, and by keeping this in mind you will have a greater chance of making your painting look more realistic.

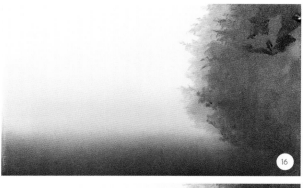

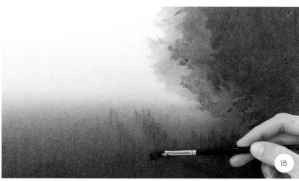

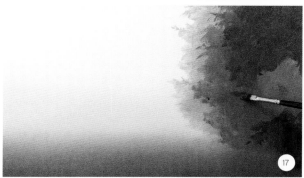

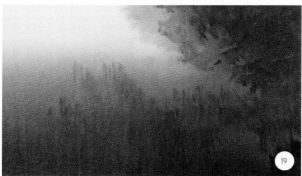

16. Now it's time to block in the final tree in this scene. Go back to your palette and create a beautiful deep green using Green Earth, Charcoal Grey and Indigo. Begin creating the shape of this third tree and keep in mind that you want this tree to be darker than the other two.

17. Make sure that you leave enough of the branches showing from the tree underneath so that it gives the illusion that there are three trees in this painting.

18. Once you are happy with how your trees look, it's time to add a tiny bit of definition to the field near the trees. Using the same brush that you used to create your trees and the same dark color, gently rough in some shadows in the field that give the illusion that there is a path or tractor tire marks coming through the tall grass.

19. Pick up a little bit more of the dark green with your detail brush. Using an up-and-down motion, transfer this color underneath the three trees, creating some shadow to make it look like tall grass is growing there. This doesn't need to be very detailed at all; we are simply creating the illusion of shapes in the shadow area.

20. Clean your larger blending brush well on a rag or paper towel. Without adding any paint to the brush and using gentle circular motions, go back and forth from the top of your field down to the bottom. You barely want any pressure on your brush at all. What you are doing is softening the field ever so slightly and making it look as though the mist has settled onto the top of the tall grasses you created.

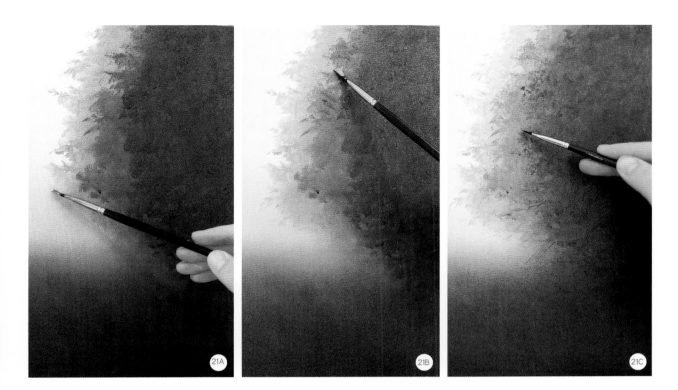

21. Once you're happy with how everything looks, it's time to add the final detail work to your three trees. Make sure that you use the right shade of green for each tree as you add your final brush work to it. With one of your small detail brushes, use the tip to create the illusion of tiny branches or little clusters of leaves coming out from the edge of the tree. Spend some time in this final stage making these trees come to life in a way that feels right to you!

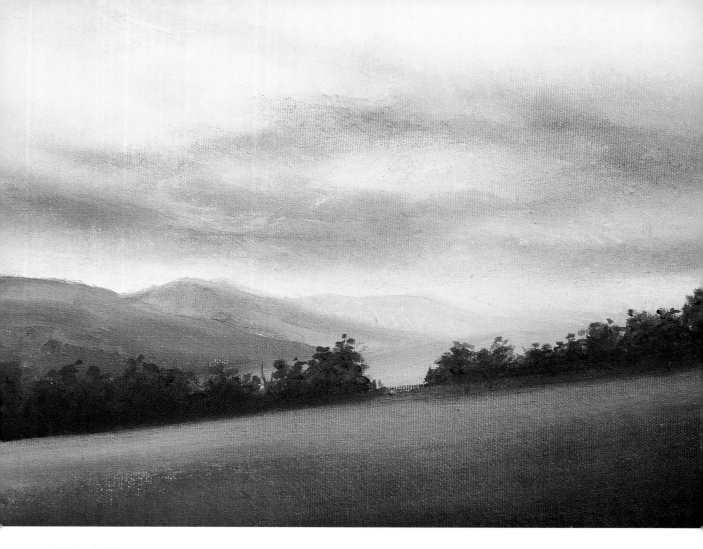

THE FOOTHILLS

Learning how to create an oil painting with multiple layers can be very challenging when you are first starting out on your creative journey, so I am going to walk you through this dreamy country scene from start to finish and show you how it's done!

In this 9 x 12–inch (22 x 30–cm) countryside painting, I am going to break each layer down into manageable steps so you can transfer these skills and techniques into other paintings moving forward. Make sure you take your time within each section and really get a feel for how your brush can transform the canvas.

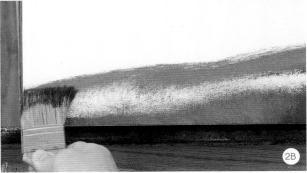
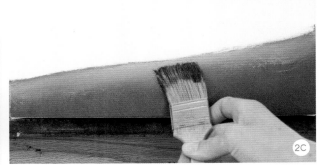

MATERIALS

Canvas Size: 9 x 12–inch (22 x 30–cm) canvas
Paint Colors: Titanium White, Green Earth, Charcoal Grey, Indigo, Cerulean Blue
Medium: Walnut Alkyd Oil (speeds up drying time) or walnut oil (slows down drying time)

BEFORE YOU BEGIN

The composition for this painting follows the rule of thirds, with our cloud line resting along the upper-thirds line, our field resting around the bottom-thirds line and our focal point sitting in the middle right section of the painting.

Make sure that you do not use very much medium when you are mixing the different colors for this painting. You want to be able to do lots of subtle blending work within the different layers of this landscape, and having a thicker consistency to the paint will make that blending much easier for you.

Feel free to stop at the end of any of the steps to let your painting fully dry before continuing on, if needed.

THE PROCESS

1. With your size 24 blending brush, mix Green Earth and a little bit of Titanium White on your palette. Try to only add a very small amount of medium to your paint for these base layers.

2. Begin blocking in the grassy field that rests in the foreground of the painting. With a medium amount of pressure on your brush, work it in a circular motion from right to left filling in the entire section with the beautiful green color you created. Once you have blocked in the bottom portion of the canvas, without cleaning off your brush, mix a small amount of Titanium White into the bristles. Transfer a brush-width of this lighter green along the top of your hill to give it a three-dimensional appearance.

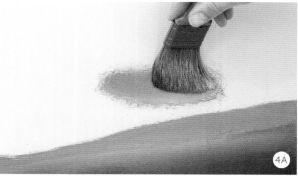

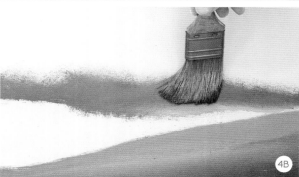

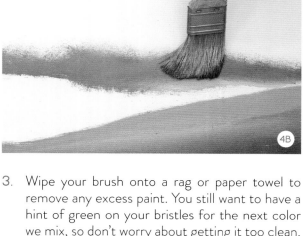

3. Wipe your brush onto a rag or paper towel to remove any excess paint. You still want to have a hint of green on your bristles for the next color we mix, so don't worry about getting it too clean. The reason why we want a tiny hint of green in this mixture is because colors on the ground actually reflect up into the sky in the natural world. They are incredibly subtle and sometimes imperceptible, but one of the biggest tricks to creating realistic landscape paintings is to ensure that little hints of the colors that you use on the ground are also added to the colors you use in your sky.

On your palette, mix together Cerulean Blue, a tiny bit of Indigo and some Titanium White. You want to create a nice, soft blue that's going to be used for the bottom layer of clouds in the sky.

4. Being sure to leave the canvas blank where the three small mountains are going to sit along the left side of the horizon, transfer that blue color onto the bottom half of the sky using circular motions and a lot of pressure on your brush.

5. With a clean 1-inch (2.5-cm) blending brush, mix together Indigo, Cerulean Blue, a tiny bit of Charcoal Grey and a few small drops of medium on your palette. With circular motions and a lot of pressure on your brush, transfer that darker color directly above the area that you just blocked in, coming up about 2 to 3 inches (5 to 7 cm) or so.

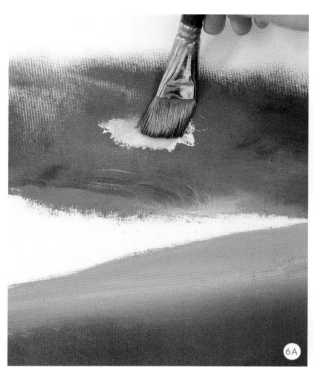 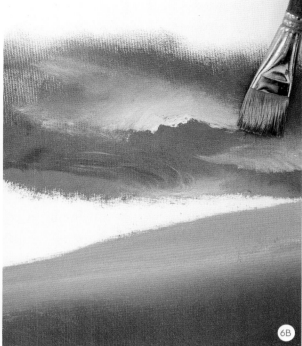

6. Now for one of my favorite parts: Without cleaning the brush you were just using, pick up some Titanium White and transfer it into the middle of that shadow color you just put down on your canvas. You are now going to begin creating different layers of clouds within your sky. Using a lot of pressure and small circular motions, transfer this lighter color into two or three different areas, as shown above. These clouds are going to very rough and wispy, so try to let loose and be a little messy with your brushstrokes.

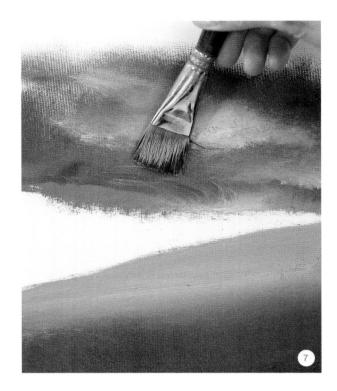
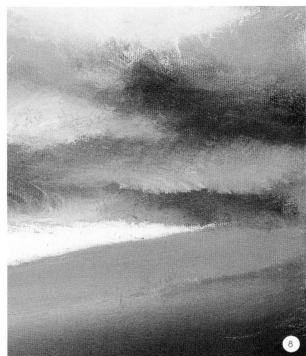

7. To give the illusion of a cloud trailing off into the sky, gradually lessen the pressure on your brush as you move away from the center of your cloud and off into the distance. Where you want your cloud to fade, slowly lift your brush off the canvas as you reach that area. This is a great technique to practice, as it really helps create realistic looking clouds!

8. Without cleaning off your brush, pick up some more Titanium White and finish blocking in the remaining section of sky at the top of your canvas. You really want to avoid adding medium to your paint at this stage because it makes softening the transition between shadows and highlights a lot easier if the paint is slightly thicker.

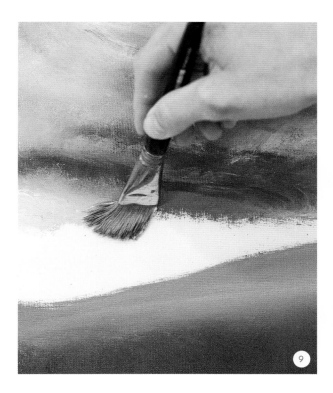

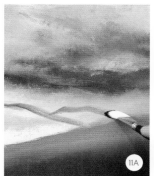

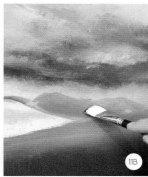

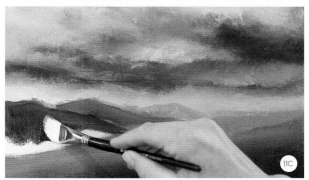

9. Once you're happy with how your skyline is looking, add some more Titanium White to your brush and finish blocking in the bottom section of your sky directly above your horizon line.

10. Wipe the excess paint off your 1-inch (2.5-cm) brush and mix together a little Charcoal Grey. and Indigo on your palette. This is going to be the color that you use for the darkest mountain. On a different section of your palette, add a tiny bit of Titanium White to your brush and mix it around in that space. This color should be slightly lighter than the last one and will be what you use for the mountain that is in the middle. Lastly, add a tiny bit more Titanium White to your brush and mix it around on a new section of your palette. This is the lightest color of the three and will be used for the mountain that is furthest in the distance.

11. We are going to create three small mountains that trail off into the distance on the left side of the canvas. You want the mountain that's farthest in the distance to be the lightest of the three.

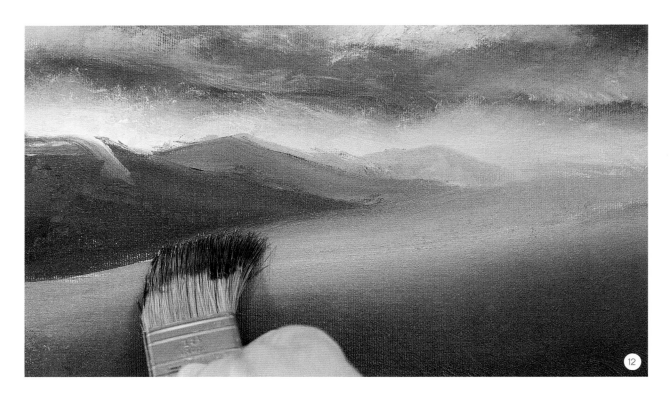

12. Take your blending brush and wipe off as much of the paint as possible onto a rag or paper towel. Gently pull this clean brush along the horizon line from right to left to clean up any random brushstrokes that may have strayed into this area. You can use this trick at any point throughout this project if you feel that your horizon line needs to be cleaned up a bit or re-established.

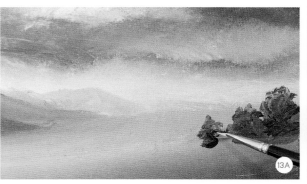

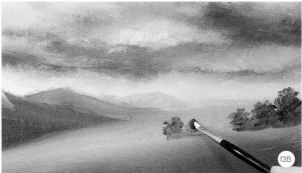

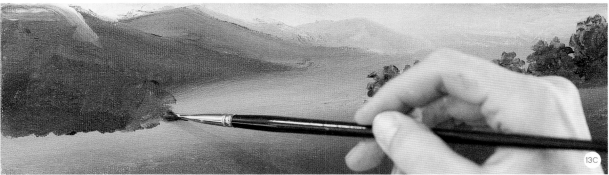

13. Now we get to begin creating the tree line that breaks up the field in the foreground. Create a nice rich green by adding Green Earth with a tiny bit of Indigo. Using one of your smaller detail brushes, start adding small trees or bushes about 1 inch (2.5 cm) below your horizon line. Make sure that you add variation to each tree and leave different spacing in between groups of them as well. By doing this, you're drawing the eye out into the distance and making your trees look very realistic.

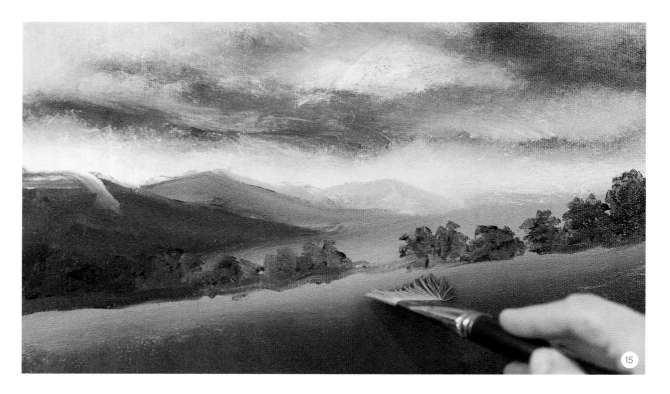

14. Be careful not to fully cover the small section of green field that is behind this line of trees you are creating. That area is going to be the focal point for this piece and needs to remain exposed.

15. When you're happy with how your trees look, pick up your 1-inch (2.5-cm) blending brush and clean off any excess paint. Gently pull your brush along the bottom of the tree line from one side of the canvas to the other without lifting it up. This is going to smooth out your horizon line once again.

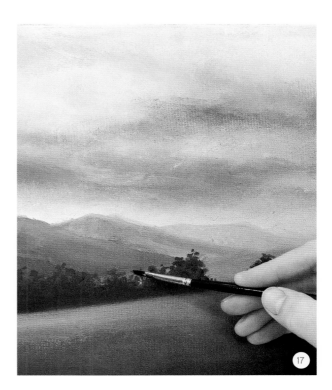

16. Next, you want to make sure that your mountain range has nice definition up on the peaks. Using the proper color that you created for each mountain peak, and being sure to start at the mountain that is farthest away, take your 1 inch blending brush and gently pull it down the face of that mountain towards the horizon line. This will help draw the eye towards the focal point and soften the mountain range within the scene. Then take that same brush and gently redefine the top of the mountain. Do this for all three of the mountains in this section.

17. Finally, to finish your painting, add a little bit more detail work to the line of trees throughout the midsection. With your detail brush, pick up some of that lovely green on your palette and use really fine brushstrokes to create definition on the trees that are sitting on the horizon.

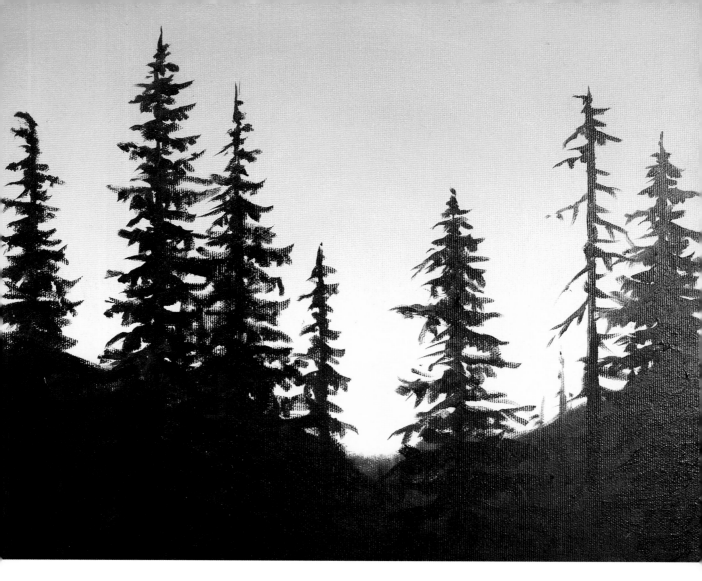

VIBRANT
SUNSET

Mother Nature always has a way of creating the most incredible sunsets with the most beautiful and vibrant colors. I am going to you show a very simple way to create one of these epic West Coast sunsets through easy-to-follow steps and a simple color palette.

MATERIALS

Canvas Size: 11 x 14–inch (28 x 35–cm) canvas
Paint Colors: Titanium White, Naples Yellow, Cadmium Yellow, Alizarin Crimson, Indigo
Medium: Walnut Alkyd Oil (speeds up drying time) or walnut oil (slows down drying time)

BEFORE YOU BEGIN

In this 11 x 14–inch (28 x 35–cm) painting, the focal point will be the bright yellow light that is glowing on the horizon in the midsection of the canvas. Getting the blending work just right is very important for this painting, so make sure you spend time working on each step of the process we are about to go through.

Whenever you need to mix any Cadmium Yellow or Alizarin Crimson on your palette, make sure you only add a very tiny amount of each at a time. They are very overpowering colors, so please keep that in mind.

You can create this whole painting using the wet-on-wet technique, or you can stop and let it dry after you blend in the sky, if you need to.

As you work through this painting, be sure not to wash your brushes in between any of the steps. If you only have a few brushes on hand and need to reuse them, just wipe your brush back and forth onto a rag or paper towel repeatedly until all the excess paint comes off.

THE PROCESS

1. With your size 24 blending brush, mix a tiny bit of Naples Yellow, some Titanium White and a small amount of the medium together on your palette. Make sure not to use too much medium because it will make the paint very thin and challenging to work with. Across the middle section of your canvas, block in this beautiful, warm yellow color.

2. Using the same brush, go back to your palette and mix together a small amount of Cadmium Yellow, some Naples Yellow and a very small amount of Alizarin Crimson. Add a little bit of Titanium White to soften the color and then transfer it onto your canvas directly above the section you just blocked in.

3. Wipe your brush onto a rag or paper towel so that there is no excess paint left on the bristles. Using the same transition blending technique that you practiced at the beginning of the book, gently work the transition line between the yellow and the color that you just put down.

4. Using gentle circular motions, begin working your brush across the canvas, softening the transition line. With each pass you make, be sure to wipe any excess paint off your brush before repeating the process. This will help preserve that lovely yellow color that we used to block in the first layer of the sky, as you blend.

5. This technique takes a lot of practice, so go easy on yourself if you can't get it just right on your first attempt. If you have too much paint on your canvas, or if you have too much medium and the colors aren't quite blending the way you want, just wipe the canvas off with a rag or paper towel and begin the process again, adjusting accordingly. Do not rush through this step. This is where the best kind of growth will happen for you on your creative journey.

6. With the same blending brush, mix a tiny bit more Alizarin Crimson and Naples Yellow into the color you were just using. You want this new color to have a bright peachy or pinkish hue. Transfer this new color onto the top section of your sky using a lot of pressure and circular motions.

7. After you've blocked in that section, remove all excess paint from your brush by rubbing it back and forth onto a rag or paper towel. Then, with the same technique as before, begin working the transition line between the top two colors in the sky.

8. Be mindful to keep wiping your brush off onto a rag or paper towel after each pass you make while blending these transition lines. Although some color transferring down into the lighter section is alright, you don't want too much of it over-powering your midsection. Continue to blend your transition lines until you have a smooth, seamless background like what is shown above.

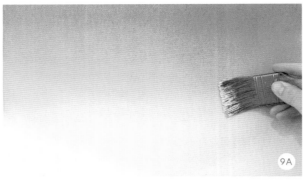

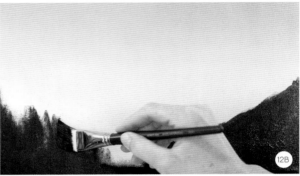

9. Because it can be challenging to keep the yellow nice and bright throughout all your blending work, grab a clean blending brush and add some of that warm yellow to the bristles. Re-apply it to the lower section of your sky with soft circular brush-strokes. You do not need a lot of pressure on your brush for this.

10. Once you're happy with how your sky looks, you can begin blocking in the base layer of where your trees are going to sit in the foreground. It is important to make sure that you're very happy with how your sky looks within your painting, because as soon as you begin blocking in the trees, it will be very hard to correct anything in the background without ruining all of the hard work you have put in so far.

11. With a 1-inch (2.5-cm) blending brush, mix together some Indigo, Alizarin Crimson and a tiny bit of Naples Yellow to create a deep, dark purple color on your palette. This is the color you will be using to paint everything that is sitting in the foreground of your painting.

12. Begin transferring some of the purple color onto the bottom section of your canvas, creating the shape of two little hills that come down to the center point of the foreground and meet.

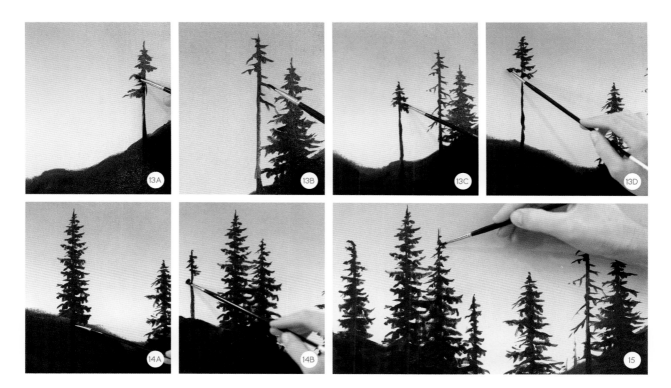

13. With your small detail brush, begin adding trees of various heights and thicknesses to the scene (see Painting Evergreen Trees, page 20). Make sure that the tips of the trees do not come above the top-thirds section of your painting. You want to keep everything feeling balanced in this piece, so you need to have some free space at the top of the canvas to achieve that.

14. Continue to add trees of various sizes across the two hills that you just blocked in. Be mindful to keep the spacing different in between each little group of trees and to slightly modify the shape of each tree as you're building up the scene. Make sure you also add a dead, standing tree in the mix as well to really make it look realistic.

15. When you're happy with your trees, use the thin tip of your smaller detail brush to add the final detail work to your forest. This is the final step for the painting, so take your time here until you feel that your painting is just right!

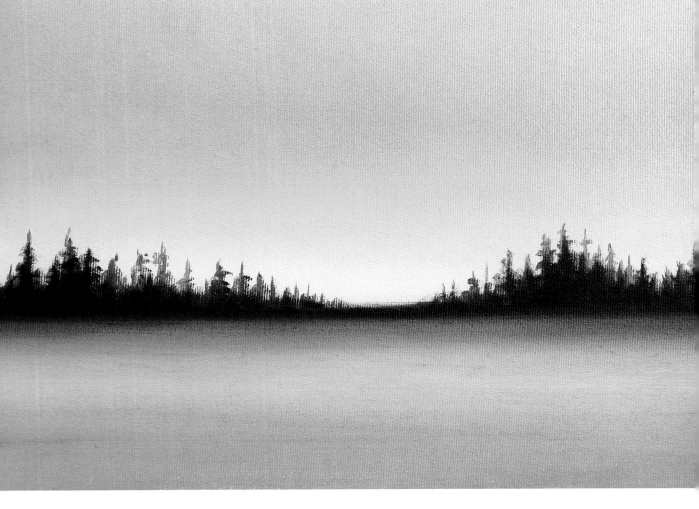

SOFT MORNING LIGHT

The warm glow of a rising sun that's about to crest over the horizon is a dreamy feast for the eyes, and I want to show you how to create that beautiful soft light with some easy-to-follow steps and a beautiful color palette.

MATERIALS

Canvas Size: 9 x 12–inch (22 x 30–cm) canvas
Paint Colors: Titanium White, Naples Yellow, Alizarin Crimson, Cerulean Blue, Indigo
Medium: Walnut Alkyd Oil (speeds up drying time) or walnut oil (slows down drying time)

2A

2B

BEFORE YOU BEGIN

The composition for this 9 x 12-inch (22 x 30-cm) painting follows the rule of thirds, and our horizon line will sit along the bottom-thirds line of the canvas. When you add Alizarin Crimson to a color that you are mixing on your palette, please be mindful to only add a small amount of it at a time because it is a very bold color and can quickly take things over.

You can create this whole painting using the wet-on-wet technique, or you can stop and let it dry after you blend in the sky if you would like.

As you work through this painting, be sure not to wash your brushes in between any of the steps. If you only have a few brushes on hand and need to reuse them, just wipe your brush back and forth onto a rag or paper towel repeatedly until all the excess paint comes off.

THE PROCESS

1. With your size 24 blending brush, mix together Titanium White, tiny bits of Alizarin Crimson and Naples Yellow and a smidge of Cerulean Blue on your palette. Be sure to only add a very small amount of your medium to the paint so that it doesn't become too thin. You want a very soft pink color that's going to rest on either side of your horizon line.

2. Establish where your horizon line is going to sit in your painting and use your brush to pull the color that you made across the canvas from left to right.

 Because this is a reflection scene, take that same color and transfer it directly below the horizon line from left to right as well.

3. Using the same brush, add a little bit of Cerulean Blue and a tiny bit Alizarin Crimson to the mixture that you just made. Transfer a single line of that new color directly above and below the last section you just worked on.

4. Add a little bit more of this color to your brush and, with large circular motions, block in the remaining section of the sky that has yet to be painted.

5. Wipe off the blending brush onto a rag or paper towel and mix Alizarin Crimson and Naples Yellow together on your palette to create a warm, vibrant color.

6. With a lot of pressure on your brush and using small circular motions, start on the lefthand side of your canvas and transfer this color onto the transition line between the dark color and the light color that you previously blocked in. Then transfer some of this warm, vibrant color along the very bottom of your canvas.

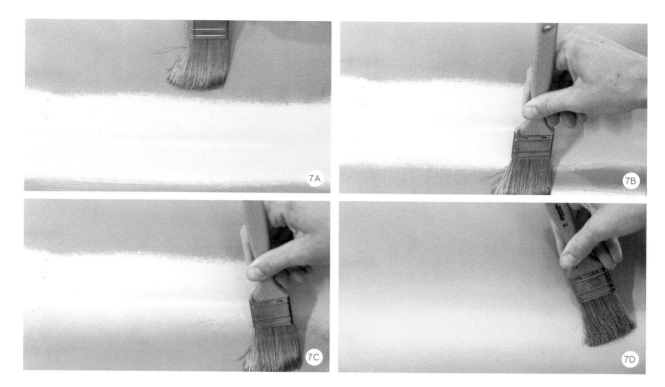

7A

7B

7C

7D

7. Once you transfer the warm, vibrant color all the way across that transition line, wipe your blending brush off onto a rag or paper towel so that all the paint is off its bristles. Then with a gentle amount of pressure and using soft circular motions, keep working your brush across your canvas back and forth, continuing to blend that color up into the sky above it until you can no longer make out where the color ends and the other begins. Repeat the same process for the bottom section of the canvas as well.

8. This technique takes a lot of practice, so be sure to take your time and really get a feel for how you need to move your brush along the canvas to achieve this effect.

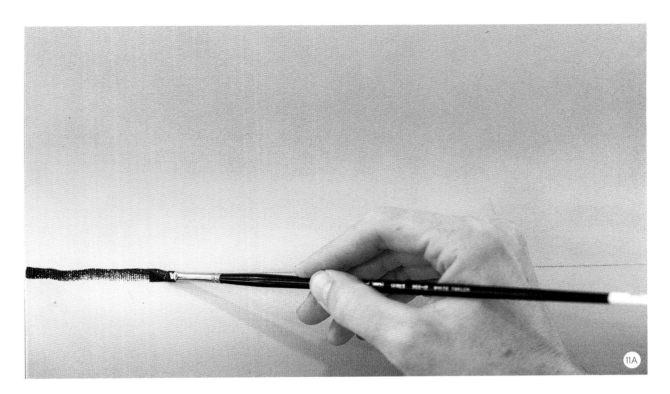

9. If you lost your horizon line with all the blending, take your measurement down from the top of the canvas and re-establish the bottom-third line that is your horizon. Use a straight edge and a pencil to re-establish it.

10. With your small detail brush, mix together Alizarin Crimson, Cerulean Blue and a tiny bit of Indigo on your palette. This is the dark color we are going to be using for the land and trees on our horizon.

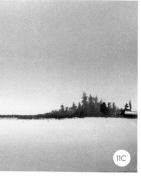

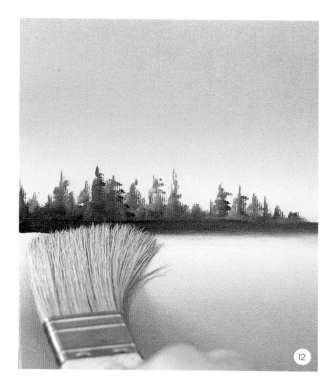

11. Using your detail brush, pull this color across your horizon line. Then, begin creating pockets of tiny trees that are coming up from your horizon line 1 to 2 inches (2.5 to 5 cm) into the sky. Have some fun playing with the different heights and shapes of these trees.

12. Once you're happy with your trees, pick up the large blending brush that you were using earlier and, using a lot of pressure, pull the brush across the bottom of your horizon line to soften the edge between where the water meets the tree line. This is just to smooth out the surface area.

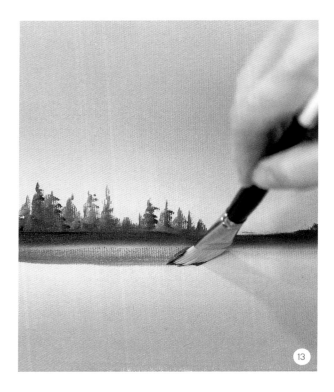

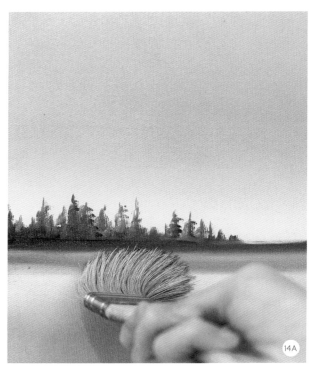

13. Now we get to establish a hint of a reflection beneath the trees you just created. Using a 1-inch (2.5-cm) blending brush, pick up some of the dark purple color you created for the tree line.

 Transfer this color onto your canvas by pulling your brush from left to right directly underneath your horizon line. You should have a soft purple in that area now.

14. Wipe off your blending brush so there is no excess paint on any of the bristles. With your blending brush, with a medium amount of pressure on the brush, gently pull it across the color you just added to the reflection area to soften it ever so slightly.

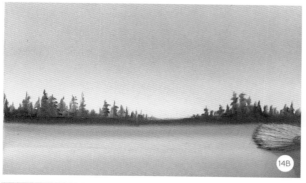

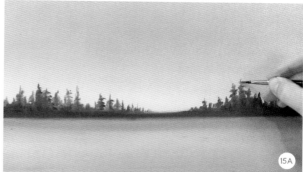

15. The last stage of this painting is to add some final detail work to your tiny trees on the horizon, and then you are all finished!

Take the detail brush that you were using to create your tree-line with earlier and, with the very tip, begin gently redefining the tops of your trees and adding some very slight branch definition. These trees are super small, so you do not need to spend too much time working on them, but it's fun to add a little bit of character to them as the final step to this painting.

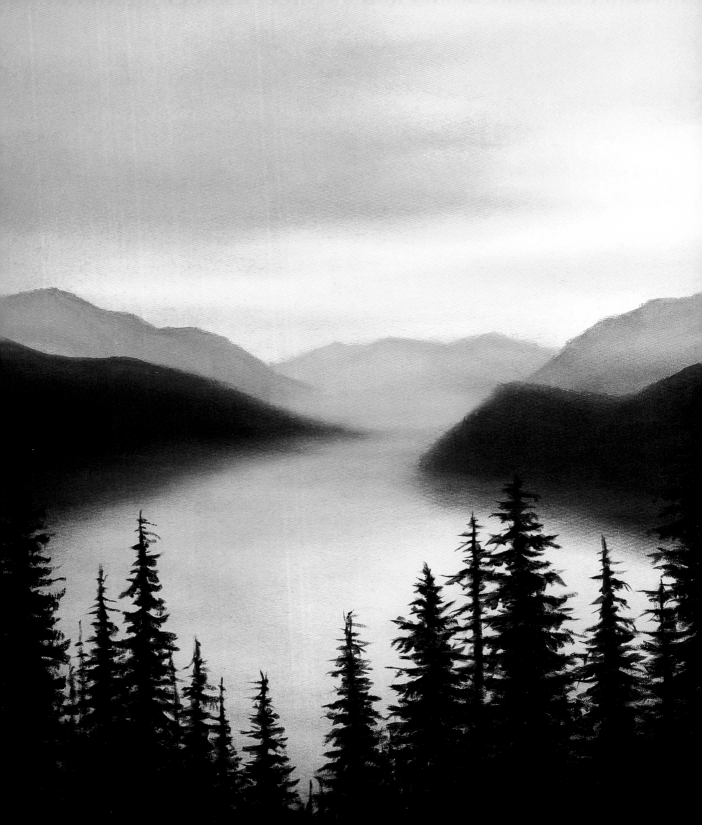

WEST COAST SUNRISE

I created this warm coastal painting to tie in every technique you have been practicing throughout this entire book. It will be so much fun channeling all you have learned into this gorgeous vista, so be sure take your time and be proud of how much you have grown throughout this process!

MATERIALS

Canvas Size: 20 x 24–inch (50 x 60–cm) canvas
Paint Colors: Titanium White, Naples Yellow, Cadmium Yellow, Alizarin Crimson, Cerulean Blue, Indigo
Medium: Walnut Alkyd Oil (speeds up drying time) or walnut oil (slows down drying time)

1

BEFORE YOU BEGIN

Feel free to stop at any time and allow the painting to fully dry before you continue onto the next step. You can also use the wet-on-wet technique and finish the painting all in one go if that suits you, too.

The canvas I'm using is 20 x 24 inches (50 x 60 cm), but feel free to use whatever size canvas you're most comfortable with. Make sure to add only minimal amounts of medium to your paint mixtures as well. It will really help your transition blending if the paint is not too thin.

As you're working through each step of this painting, be sure to refer to the main reference image of the finished piece to see how each section should look once it's finished. Also, be sure not to wash your brushes in between any of the steps. If you only have a few brushes on hand and need to reuse them, just wipe your brush back and forth onto a rag or paper towel repeatedly until all the excess paint comes off.

THE PROCESS

1. With your size 24 blending brush, create a warm, peachy color by using Titanium White, Naples Yellow and a tiny bit of Alizarin Crimson and a tiny bit of Cadmium Yellow. Transfer a 3- to 4-inch (7- to 10-cm) layer of this color onto your canvas just below the top-thirds line.

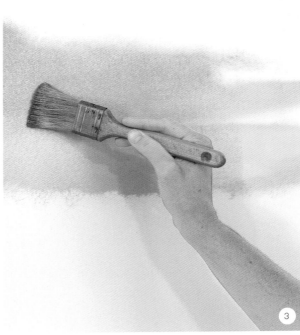

2. On your palette, add a tiny bit more Alizarin Crimson to that same color. With a circular motion and a lot of pressure on your brush, transfer this new color into the area just above the section you just blocked in.

3. Remove the excess paint from your brush by wiping it back and forth onto a rag or paper towel. Begin softening the transition line between the two colors that you just blocked in using the same technique we have practiced in all the other paintings in this book. Be sure to wipe your brush off with each pass to keep the colors from getting too muddied.

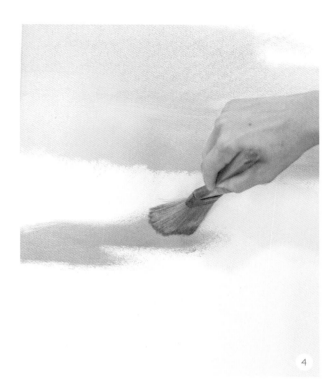

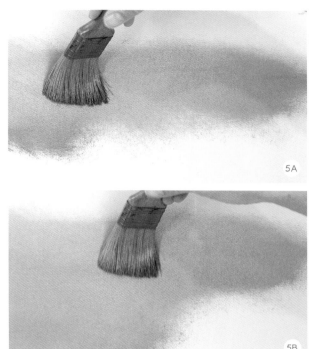

4. We are now going to begin blocking in the water reflection on the bottom half of the canvas. With the same blending brush, create a little bit more of the color that you used for the top portion of the sky by mixing together some Titanium White, Naples Yellow and a little bit of Alizarin Crimson. With a lot of pressure on your brush and small circular motions, begin pulling this color across the canvas, just below the center line. You need this section of color to be 3 to 4 inches thick and for it to come three quarters of the way across the canvas.

5. Back on your palette, add a tiny bit of Alizarin Crimson, Cerulean Blue and a very small amount of Indigo to the color that you just mixed. What we're trying to achieve is a warm purple color for the next section.

With circular motions and a lot of pressure on your brush, transfer that color into the area directly below the center line you just established in the last step.

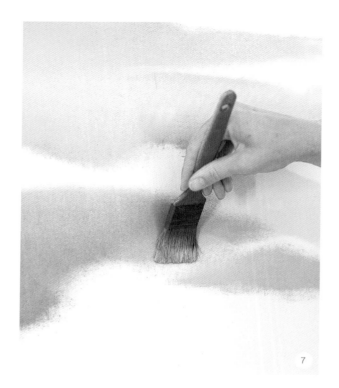

6. Completely wipe off your blending brush so there is no excess paint left on the bristles, and then mix together some Titanium White, Cadmium Yellow, Naples Yellow and a tiny bit of Alizarin Crimson on your palette. You want to keep this color more on the orange side, so be sure not to add too much Alizarin Crimson to the mixture. If you did add too much crimson, don't sweat it. To correct it, just add a tiny bit more Cadmium Yellow, and it should be closer to the color you are looking for.

7. Begin transferring this color on the righthand side of the canvas, starting just below the halfway mark, directly across from the area you were just working on. If you take a quick peek at the reference painting, you will see the area as well.

8. Continue spreading this color down the canvas in a thin layer until you're near the bottom-thirds line.

9. On your palette, mix together Alizarin Crimson, Cerulean Blue, a tiny bit of Indigo and a little bit of Naples Yellow. You want to create a soft purple color that will be used both at the top of your skyline as well as in the bottom of your water reflection.

10. Using your blending brush, begin transferring this color into the top left section of your painting using circular motions and a lot of pressure.

11. Once you have blocked in that top cloud section with the same color, also block in the bottom section of the canvas and bring the color halfway across the painting from the lefthand side.

12. If you take a quick look at the image in the next step, you will see a solid line of a warm Crimson color spanning from the left side of the canvas three quarters of the way across the sky, directly below the purple section. That is what we are going to create right now in this step. Without wiping off your blending brush, mix a little bit of Alizarin Crimson into the bristles. Take your brush and gently pull it across the canvas just below the purple area in the sky. You might need to make a couple passes with this color to make it stand out, but it will create a beautiful cloud within your scene.

13. Clean off the brush you are using by wiping it across a rag or paper towel. On your palette, mix together some Titanium White, Naples Yellow and a hint of Cadmium Yellow.

14. With your large blending brush, use this color to block in part of the sky on the right side of your canvas and to create a little highlight under the pink cloud that we created.

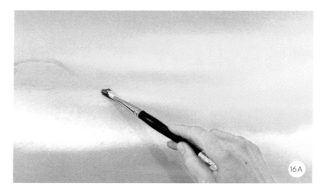

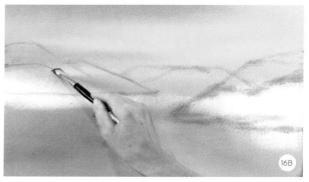

15. Without cleaning off your brush, mix together Alizarin Crimson, Cadmium Yellow, Naples Yellow and a small amount of Titanium White on your palette. Use your brush to transfer this color onto the remaining section of the sky that has yet to be blocked in.

16. Once you're happy with how the sky and the water refection are beginning to look, you can begin blocking in the mountain range that sits in the middle section of this painting.

Make sure that you really study the reference painting to get a good feel for where the mountains should sit within your painting. I have my mountain range hovering in the middle section of my canvas.

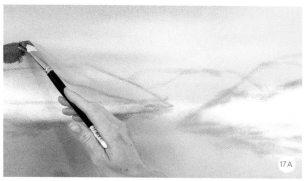

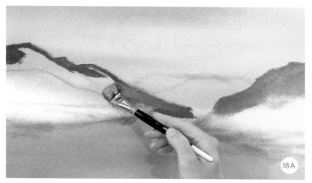

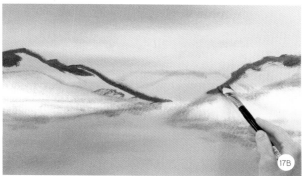

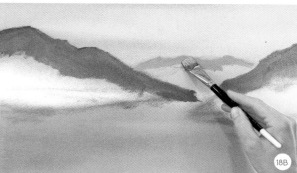

17. Using your 1-inch (2.5-cm) brush, mix together Indigo, Cerulean Blue, Alizarin Crimson and a tiny bit a Titanium White on a clean section of your palette. Take this brush and begin blocking in where you want your mountains to sit within your scene.

 These layouts take a lot of practice and patience. Don't worry if you do not get it on the first try and you need to fix something. You can easily remove any lines that you make in this section by taking your blending brush that has the same

background color on it and gently moving it in a circular motion over the area you'd like to change. This is one of the reasons why I love oil painting so much—you're never stuck with what you first put on a canvas.

18. With the 1-inch (2.5-cm) blending brush, pick up that nice, dark purple color you made for the outlines and begin blocking in the top half of your mountains. After you have covered the ridges with the dark color, add a tiny bit of Titanium White to your brush and block in the top half of each of your three mountain ranges, making sure that the mountain farthest away is the lightest.

19. Wipe off your big blending brush on a rag or paper towel and use the brush to gently soften the area where your mountains all meet on the horizon line. This subtle brushstroke will create the feeling of distance and depth within the painting.

20. Next, we are going to block in the two dark mountains that are closest to the foreground on the horizon line. With your 1-inch (2.5-cm) brush, mix together some Indigo, Cerulean Blue and a tiny bit of Alizarin Crimson on your palette. Use this color to create two mountain shapes on either side of your horizon line in the foreground.

You do not want these mountains to come up higher than the lighter ones behind them, so be sure to keep that in mind as you work at establishing how they will fit into your scene. Remember to keep referring to the reference image for this painting as you slowly build up these mountains, so that you can get a good feel for how they should sit within your painting.

Once you're happy with how those mountains look, we can focus on creating their reflections in the water beneath them.

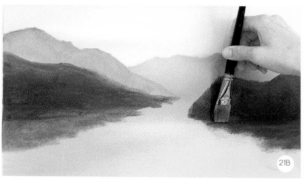

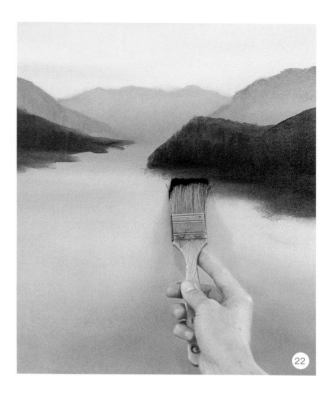

21. To create the illusion of a reflection, add a tiny bit more Alizarin Crimson to the dark color you just used. With the same 1-inch (2.5-cm) brush, begin transferring that color into the water beneath the mountains. Pull your brush back and forth in a straight line across the canvas to make the shadow look realistic. Be sure to pay attention to the shape of my shadow section and try and to achieve the same look within your painting.

22. After you've blocked in that color, pick up one of your blending brushes and remove all excess paint onto a rag or paper towel. With barely any pressure on your brush, gently move it back and forth about ½ inch (1 cm) each way along the transition line between the light color and the darker color you just blocked in. Be sure to clean off your brush every few strokes so that the dark color doesn't transfer into your beautiful sky reflection. This is very subtle brushwork and takes a bit of practice, so be sure to spend some time here playing around until you achieve the look you are hoping for.

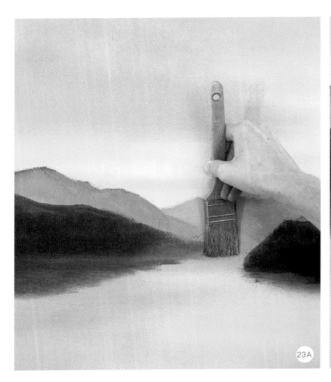

23. Clean off your large blending brush on a rag or paper towel. Dip the brush into a tiny bit of Cerulean Blue. You only want to have a very small amount of this color on your brush for this step, so dab off any extra color before you begin.

We are going to use this color to create the illusion of a soft mist resting on the horizon where all the mountains meet. With barely any pressure on your brush, use small circular motions to gently transfer some of the blue into this area. If you blend a little too hard and accidentally erase some of your mountains, do not worry. Just re-establish the mountain shape with your 1-inch (2.5-cm) brush and try again!

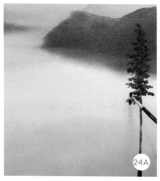
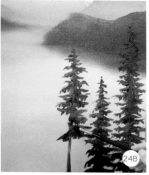
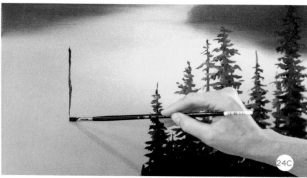
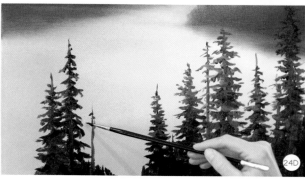
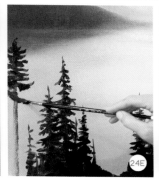
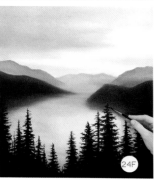

24. Once you are happy with how your sky looks and how your mountain ranges sit within your painting, you're ready for the final stage of this beautiful West Coast scene.

With your small detail brush, mix together some Indigo, Cerulean Blue and a tiny bit of Alizarin Crimson on your palette. Using the same techniques you learned throughout our earlier forest paintings, begin adding various sized trees to the foreground of your canvas.

25. Be mindful to only have one or two trees come up higher than the bottom-thirds line of your painting. You don't want to cover the beautiful mountain range that you just spent so much time working on!

As always, remember to add different shapes of trees, varying tree heights and varying spaces between your trees to make the scene look more realistic!

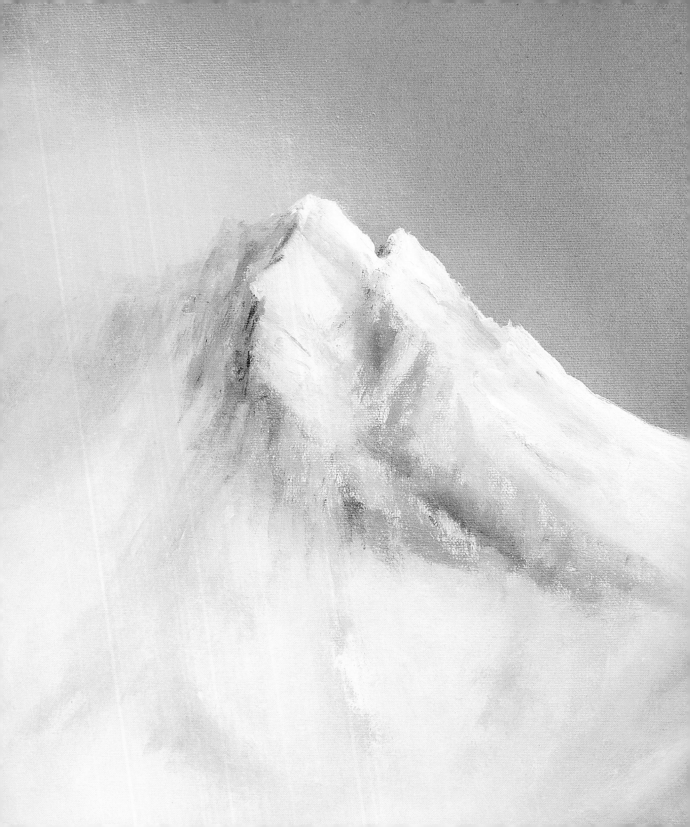

ACKNOWLEDGMENTS

There are no words to convey the depth of gratitude I have for every beautiful soul who has supported me as I found the courage to share my art with the world. Self-expression in any form can be a terrifying journey, but the constant encouragement and love from my family and friends has allowed me to really flourish as an artist.

ABOUT THE AUTHOR

Sarah Mckendry is an internationally recognized oil painter, art educator and author who has spent the last 14 years pouring her heart and soul into her craft, while also being a stay-at-home mom to her two young boys.

As a completely self-taught artist, Sarah chose to forge her own path into the art world to prove that you do not need prestigious art schools or high-end gallery representation to create a meaningful career as an artist. Sarah has been featured in multiple international publications and teaches thousands of students around the globe. Her paintings can be found in the homes and private collections of clients both near and far.

Sarah lives in Edmonton, Alberta, with her young family where she paints out of her cozy home studio.

INDEX